LGBT Brighton and Hove

LGBT Brighton and Hove

Janet Cameron

AMBERLEY

First published 2009

Amberley Publishing
Cirencester Road, Chalford,
Stroud, Gloucestershire, GL6 8PE

www.amberley-books.com

British Library Cataloguing in Publication Data.
A catalogue record for this book is available from the British Library.

ISBN 978 1 84868 717 2

Typesetting and origination by Amberley Publishing
Printed in Great Britain

CONTENTS

ACKNOWLEDGEMENTS

My thanks to the LGBT community and especially to the following people, for all the help and encouragement offered to me while writing this book. I couldn't have managed without them.

In alphabetical order: Ben Cohen, Phillip Fifton, Ron Forrest, Revd Debbie Gaston, Jamie Hakim, Trevor Love, John McPherson, Warren Nelson, Rictor Norton, Ann Perrin, Queen Josephine, Pamela Rose, Andrew Wikholm, Kate Wildblood.

Local historian, Geraldine Curran, for reading my manuscript and making helpful suggestions.

Award-winning photographer Dean Thorpe, www.aspexdesign.co.uk, for allowing me to use his stunning Pride photographs.

Gareth Cameron for taking specific shots for me.

Paul Chessel, Adam Tayler, Brightwaves' website, and the Legends Hotel, for allowing their photographs to be used.

The staff at The History Centre, The Pavilion, for their helpfulness.

My editor, Sarah Flight, and designer, James Pople.

(Please note that people depicted in the Pride images may be LGBT or heterosexual and that anyone is welcome to help celebrate at Pride events.)

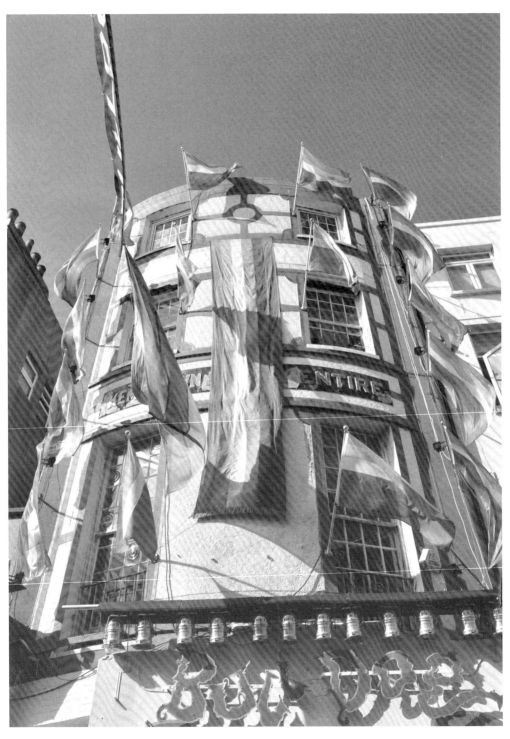

The Pride six-colour rainbow flag, 2009. The 1978 version had two additional stripes, pink and turquoise. (© Gareth Cameron)

INTRODUCTION

I am indebted to the LGBT community in Brighton and Hove for all the friendly help, advice and encouragement they have offered while writing this book. My research comes from newspaper and journal reports, from literature and from trusted, referenced websites. I have also been privileged to include contributions from those who have allowed me to use their personal stories, memories and experiences.

Sources are acknowledged either on the title page of this book or in the bibliography. I have taken care to verify specific facts from relevant sources, and have included names except where anonymity has been requested and where it seems appropriate. If I have unwittingly made any errors please refer your query to my publishers so this can be corrected when the book is reprinted. I hope my prose will become more inspirational as the story unfolds, showing the achievements both of individuals and organisations whose determination and courage has helped, and is still helping, to implement changes in attitudes.

> A gondola, the still lagoon;
> A summer's night, an August moon,
> A splash of oars, a distant song,
> A little sigh, and – was it wrong?
> A kiss both passionate and long.

> Extract from 'On the Lagoon' by Marguerite Radclyffe Hall,
> from *'Twixt Earth and Stars* (1906).

> No sentimentalist, no stander above men and women or apart from them,
> No more modest than immodest.

> Unscrew the locks from the doors!
> Unscrew the doors themselves from their jambs!

> Whoever degrades another degrades me,
> And whatever is done or said returns at last to me.

> Through me the afflatus surging and surging, through me the current and index.

> Extract from 'Song of Myself' by Walt Whitman, Chapter 24,
> from *Leaves of Grass* (1855).

1

LABELS AND EUPHEMISMS

When looking at period newspaper reports, it's necessary to 'read between the lines'. Specifics were seldom stated in relation to same-sex activity, and those victimised for practising homosexuality could be said to have committed 'an abominable offence' or 'an unnatural act'. We know the word 'homosexual' was not in common use until the early twentieth century, while 'gay' came into current use in the late twentieth century. 'Queer', once used as a derogatory term in the mid-twentieth century by homophobic people, has now been reclaimed by some gay men. Since the 1980s the word's use has been undergoing a process of being overturned semantically as a gesture of defiant pride.

Most people are aware the word 'lesbian' is derived from the ancient Greek poet Sappho and her followers who inhabited the island of Lesbos – the word is claimed to have been appropriated into the English language from around the 1780s, although, like 'homosexuality', it was not in common use until the early twentieth century. It appeared in medical journals from around 1925.

Lesbian lovemaking was called 'The Game of Flats' during the eighteenth century, and lesbians were described as 'sapphists' in the eighteenth and nineteenth centuries (although this word was equally applied to promiscuous heterosexual women). During the nineteenth century, lesbians were also known as 'tribades', a word employed, according to historian, Rictor Norton, in Greek and Latin satires as far back as the first century. He says, '"Tribade" occurs in English texts from at least as early as 1601 to at least as late as the mid-nineteenth century before it became self-consciously old-fashioned.'

Today this word can be used to describe a position of lovemaking, from the Greek *tribein*, to rub. (The name of the pop group 'Scissor Sisters' is also derived from lesbian lovemaking according to an article entitled 'Scissor Sisters: On the Cutting Edge' by Richard Harrington, *The Washington Post*, 7 January 2005. Richard Harrington says, 'The name is a slang term for a lesbian sexual position as well as the group's literal logo.') The terms 'tabbies' or 'toms' were also used for lesbians from the nineteenth century through to the early twentieth century. Many negative euphemisms for lesbianism appeared in newspaper reports, for example deviant, degenerate, delinquent, perverted, neurotic. Lesbianism, in contrast to male homosexuality, was never criminalised (partly thanks to Queen Victoria, who was stubbornly in denial about the whole thing) and went, to a large degree, unrecognised by the general public.

Information is also scant in the eighteenth century. Overt references to homosexuality were suppressed in newspaper reports and by the clergy and families, although euphemisms continued to be used. Lesbianism found expression in literature during

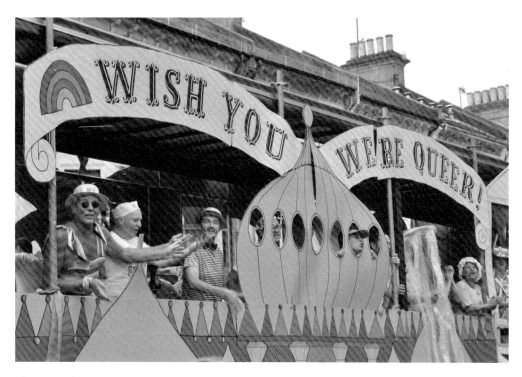

Float at Pride 2009.

the nineteenth and twentieth centuries through the use of pseudonyms, ambiguity, metaphor or extended metaphor, although this sometimes resulted in litigation. Subtext plots were also used in novel writing and were intended to be recognisable as such by lesbian readers.

2

EDWARD CARPENTER
A SEXUAL LIBERATIONIST

Many writers used their work to bring public attention to the many injustices towards homosexual men and lesbians. I have aimed for a selection that's representative of a variety of experience, produced by writers wanting public recognition and the right to sexual freedom. In some cases, the writers show a feisty disregard for public opinion in the face of intractable opposition and a hostile environment.

Edward Carpenter (1844-1929) lived, as a child, at 45 Brunswick Square, Hove and when he was ten, he attended Brighton College. It was around this time he first became aware of feelings of affection towards his own sex. In his autobiography, *My Days and Dreams*, Carpenter says:

> The trouble in schools from bad sexual habits and frivolities arises greatly – although of course not altogether – from the suppression and misdirection of the natural emotions of boy-attachment. I, as a day boy, and one who happened to be rather pure-minded than otherwise, grew up quite free from these evils: though possibly it would have been a good thing if I had had a little more experience of them than I had. As it was, no elder person ever spoke to me about sexual matters . . . I suppose it was in consequence of this that I never saw anything repellent or shameful in sexual acts themselves.

Then, in 1877, having left Brighton, Edward Carpenter met the great American poet, Walt Whitman. He'd already 'found himself' through his reading of the colourful, gay poet, around 1869. 'It was not till I read Whitman – and then with a great leap of joy – that I met with the treatment of sex which accorded with my own sentiments.' Edward Carpenter considered these feelings were natural just like any other bodily function and he wondered why there was so much fuss and so many lies and giggles.

RESPECT FOR WOMEN

Throughout his life, Edward Carpenter was a campaigner for feminism and sexual freedom, issues that consistently informed his professional career and gave inspiration and hope to others. In his autobiography, he explains his view on homosexuality: 'The Uranian temperament in Man closely resembles the normal temperament of Women in this respect, that in both Love – in some form or other – is the main object of life.' He says that in a 'normal' (*sic*) man, love, as a rule, is secondary to ambition, moneymaking, business and adventure. Further, he says, most men don't realise the grief endured by

Edward Carpenter spent his childhood in this house in Brunswick Square, Hove.
(© Gareth Cameron)

thousands of women 'in the drying-up of the well-springs of affection as well as in the crucifixion of their physical needs'.

Carpenter recognised that these sufferings were the inspiration for the Women's Movement, 'I do not practically doubt that the similar sufferings of the Uranian class of men are destined in their turn to lead to another wide-reaching social organisation and forward movement in the direction of Art and Human Compassion.'

A COVER FOR THE GENDER OF THE SOUL

In her dissertation 'The Muted Lesbian Voice: Coming out of camouflage' (1989), Nickie Hastie, the writer, mentions Edward Carpenter's theory of the 'trapped soul'. Hastie says, '. . . according to Carpenter, in the homosexual, the embryo's emotional and nervous regions (the 'soul') develop along a masculine line, while the outer body develops along a feminine line, or vice versa, and the individual's personality traits are considered to correspond to the soul's gender. The theory has links also with transvestism, for just as the body acts as a cover for the gender of the soul, clothing can disguise one's true sex.'

In 1890, Edward Carpenter openly began a relationship with George Merrill, whom he described as a man who was found attractive by everyone, yet, because of his loving nature and passion, he was not wholly 'respectable'. George cared nothing for public opinion and was unconcerned with what any individual thought of him. When they met, his wistful expression told Edward Carpenter that he was 'not satisfied in his heart'.

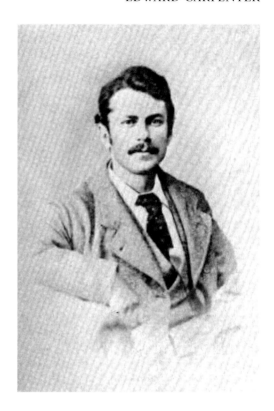

Edward Carpenter, a portrait.

Edward Carpenter's book *Homogenic Love* was published in 1895 and in 1908 he published another influential book on homosexuality, *The Intermediate Sex*. After the First World War, the couple moved to Guildford where they lived out the remainder of their lives. Carpenter is credited with setting up the British Society for the Study of Sex Psychology.

ADMIRATION FROM E.M. FORSTER

E.M. Forster was, much later, to honour Edward Carpenter for being the direct inspiration behind his novel of homosexual love, *Maurice*. It's included here as it provides an extra insight into Carpenter's character. *Maurice* was completed in 1914, but published posthumously in 1971. In his 'Terminal Note' to the book, which was added in 1960, Forster says, 'Carpenter had a prestige which cannot be understood today. He was a rebel appropriate to his age . . . he was a believer in the Love of Comrades . . . It was this last aspect of him that attracted me in my loneliness. For a short time he seemed to hold the key to every trouble.'

Forster adds in his 'Terminal Note' that Carpenter's partner, George Merrill, touched his (Forster's) backside very gently, just above the buttocks, and that he found the sensation unusual and still remembered it, 'as I remember the position of a long vanished tooth'.

3

OSCAR WILDE

NOTHING TO DECLARE BUT HIS GENIUS

WILDE QUARRELS WITH BOSIE IN BRIGHTON

The alliance of Oscar Wilde (1854-1900) with Lord Alfred (Bosie) – which eventually led to his downfall – took a turn for the worse in October 1894 in Brighton. Bosie had been lodging in Worthing but informed Oscar he would prefer to stay at a good hotel in Brighton.

Bosie became ill with 'flu and was cared for by Oscar. The two men moved to lodgings in Brighton, where Oscar persevered with *The Importance of Being Earnest*. Then Wilde caught the disease, but Bosie was less than sympathetic and let out a hysterical outburst that convinced Oscar Wilde that his partner was going mad. Bosie grabbed some of Oscar's cash and, carrying out his previous threat, he booked himself into a hotel, sending his lover a letter saying Oscar would be footing the bill. It was Oscar Wilde's fortieth birthday when he received that malicious letter.

Incredibly, Oscar Wilde forgave Bosie for his disloyalty.

On 18 February 1895, the Marquess of Queensbury, John Sholto Douglas, a Scottish Peer, left a card at the Albemarle Club for Oscar Wilde. Although the handwriting is not quite clear, it's believed to say: 'For Oscar Wilde posing Sodomite'. Queensbury was the father of Oscar Wilde's lover, Bosie, Lord Alfred Douglas. Oscar Wilde retaliated by suing the marquess, claiming his allegation was untrue, but Queensbury was found 'not guilty'. The playwright was arrested for committing indecent acts, suffered two trials and was found guilty.

THE MADNESS OF KISSING

At the opening of the Grand Sessions at the Old Bailey, reported by *The Brighton Argus* on 22 April 1895, Sir Arthur Hall said there was a serious charge against two men, Oscar Wilde and Alfred Taylor. (Alfred Taylor had allowed his friends to use his rooms for their assignations.) Oscar Wilde decided he would 'fight the case to the end' and said he was confident of winning.

One of the most poignant moments in the trial, as reported on the 24 May 1895 by *The Brighton Argus*, must be an extract from a letter to Alfred Douglas in which Wilde said: '. . . it is marvel those red rose-leaf lips of yours should be made no less for the music of song than for the madness of kissing.' In his defence, Wilde countered, 'It was a decent letter. It was a prose poem.' But he admitted meeting men in Taylor's rooms, saying he went there because of his vanity and love of admiration.

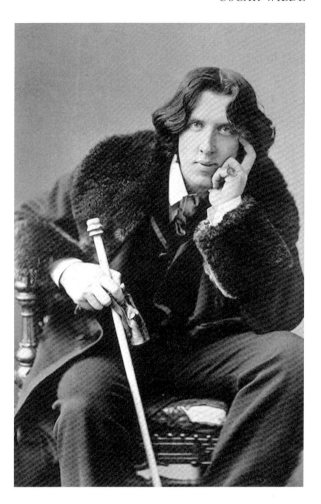

Oscar Wilde, portrait.

A LIAISON IN BRIGHTON

It was also mentioned in *The Brighton Argus* of 24 May 1895 that, in addition to other homosexual liaisons, Wilde had taken a young man called Conway to Brighton. An attempt to discover the identity of 'Conway' has uncovered two possibilities. Wilde reviewed a novelist, Hugh Conway, with much kindness in view of his own great literary genius, since the general consensus was that Hugh Conway's prose was melodramatic and slipshod. (Oscar Wilde's Reviews, www.readbookonline.net) He is also claimed to have holidayed with a young man, Alphonso Conway, in 1894, although this particular assignation took place in Worthing according to a local historian, Chris Hare, in his book, *Worthing, A History – Riot and Respectability in a Seaside Town*, published by Philimore (2008). It seems likely that the latter Conway is the one implicated in Oscar Wilde's trial.

Oscar Wilde went to prison for two years, and spent eighteen months of his time in Reading Gaol. On 29 May 1897, *The Illustrated Police News* reported that he had been secretly released from prison during the night. He went to live in Paris and died in 1890.

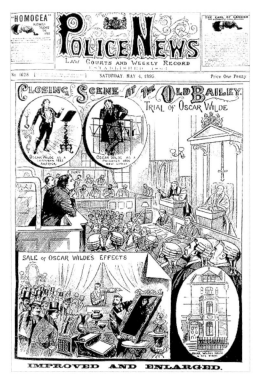
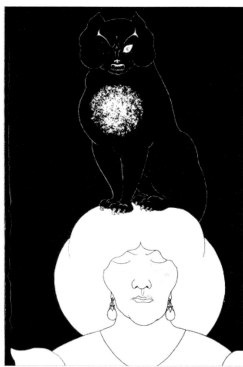

Left: Oscar Wilde in the dock, cover of *The Police News*, 4 May 1895.

Right: 'The Black Cat' by Aubrey Beardsley illustrated Edgar Allen Poe's story of the same name about the psychology of guilt.

AN ACCIDENT IN REGENCY SQUARE

One of the Marquess of Queensbury's acts against the playwright was that of trying to sabotage his play, *The Importance of Being Earnest*. On one occasion, Oscar Wilde and Bosie's carriage had veered into the railings by Regency Square. Oscar Wilde dismissed it as 'an accident of no importance'.

BROUGHT DOWN BY THE TRIAL OF OSCAR WILDE

A Victorian illustrator, Aubrey Beardsley (1872-1898), was born in Brighton at 31 Buckingham Road on 21 August 1872 and raised by his mother in poverty. He showed a great deal of promise in drawing and music from an early age, then, at Brighton Grammar School, his aptitude for drawing was encouraged by his housemaster. Beardsley, a bisexual, liked to portray himself as a dandy and said that if he was not grotesque, then he was nothing.

He became editor of the literary journal, *The Yellow Book*, although he was eventually dismissed owing to his connection with Oscar Wilde. Beardsley had met Oscar Wilde

in 1893, and provided the illustrations for his play, *Salome*, a connection that led to his downfall after Oscar Wilde's trial for indecency. Aubrey Beardsley's tuberculosis caused his early death at the age of twenty-six years.

OSCAR WILDE'S DEFIANT DECLARATION AT HIS TRIAL

It is in this century misunderstood, so much misunderstood that it may be described as the 'love that dare not speak its name' and on account of it I am placed where I am now. It is beautiful; it is fine; it is the noblest form of affection. There is nothing unnatural about it.

4

MARGUERITE RADCLYFFE HALL

A CRY FOR LESBIAN IDENTITY

I am one of those whom God marked on the forehead. Like Cain, I am marked and blemished. If you come to me, Mary, the world will abhor you, will persecute you, will call you unclean. Our love may be faithful even unto death and beyond – yet the world will call it unclean.

From *The Well of Loneliness* by Radclyffe Hall.

BRIGHTON CONNECTIONS

Marguerite Radclyffe Hall (1880-1943) was born in Bournemouth and travelled widely. She published seven novels and, although born Radclyffe-Hall, she later dropped the hyphen between her names. She often came to Brighton in the 1920s 'to party' says *Brighton Ourstory*. Later, in 1932, her lover, Una Troubridge (1887-1963) was recovering from a hysterectomy and it's claimed she and Marguerite stayed in Brighton at the Park Royal Hotel on Montpelier Road.

THE FIRST SIN . . .

Marguerite Radclyffe Hall called herself 'John' in her adult life and in her novel, the central female protagonist's father, who longs for a son, names her 'Stephen'. Stephen Gordon likes to ride and hunt and is particularly good at fencing. She wants her hair cut short and prefers men's clothes. Although the father recognises Stephen's sexual orientation from an early age, the young lesbian is confused and unhappy, knowing herself to be 'different' but not understanding why. Her mother is equally confused.

The father commits the first sin against both of them because he cannot bring himself to enlighten either his wife or his daughter about Stephen's sexuality. He quarrels with his wife Ann about her lack of love for Stephen with her boyish ways, and Ann's perception is that her husband and daughter are allied against her. 'He thought, "Tomorrow – tomorrow I'll tell her – I can't bear to make her more unhappy today." '

Stephen forms a passion for a young woman at the beginning of the novel and is cruelly betrayed by her. A later attachment is formed with a woman she meets while driving an ambulance in the First World War. Mary becomes the love of her life – although ultimately with disastrous consequences due to Stephen's sense of rejection and inevitable debilitation.

Stephen Gordon's and Mary Llewellyn's relationship is of the traditional butch/femme type, where one partner (Stephen) assumes a more assertive masculine role, while the other (Mary) is intrinsically feminine and passive. However, Stephen Gordon suspects her lover, Mary Llewellyn, is not a true sexual invert, giving rise to more confusion and Stephen's fear that she is holding Mary back; she believes that her lover would as easily have mated with a heterosexual male. Stephen's uncertainty leads to the story's tragic resolution. This butch/femme model was predominant in earlier lesbian history and later, in the late sixties and seventies, some lesbians began to react against this 'traditional' model, declaring it oppressive.

PROSECUTED FOR DESCRIBING 'INVERSION'

The love affair of the main transgendered female protagonist and another woman in Marguerite Radclyffe Hall's *The Well of Loneliness* caused heated public discourse when the novel was prosecuted in 1928 under the Obscene Publications Act. Nicki Hastie explains in 'The Muted Lesbian Voice: Coming out of camouflage' (1989): 'Radclyffe Hall's *The Well of Loneliness* formed the centre of a dramatic obscenity trial. Identifying with the sexologists' attitudes, Radclyffe Hall wished to write a sympathetic and accurate account of 'inversion'. It was her call for understanding and acceptance of the 'invert' which horrified the majority, who viewed homosexuality as the corruption of the young.' ('Invert' literally means 'to turn upside down' or 'reverse the position'.)

A CONGENITAL CONDITION

Marguerite Radclyffe Hall's belief was that lesbianism was congenital, an opposite view to that of many women involved with the suffragist movement, who asserted that a woman could 'choose to love' another woman in defiance of a patriarchal society.

James Douglas, editor of *The Sunday Express*, wrote scathingly about *The Well of Loneliness*: 'I would rather give a healthy boy or a healthy girl a phial of prussic acid than this novel . . . I am well aware that sexual inversion and perversion are horrors which exist among us today . . .The consequence is that this pestilence is devastating young souls.'

Although the book's only specific sex scene consists of the words 'and that night, they were not divided', a British court judged it obscene because it defended 'unnatural practices between women'. The trial took place on 16 November 1928. It's claimed E.M. Forster and Virginia Woolf offered to testify for this honest and sensitive novel, but the judge refused to call them.

THE APPEAL

At the London Sessions on 14 December 1928, Sir Robert Wallace KC presided over a bench of justices, including two women, to hear the appeal against the order of Sir Chartres Biron at Bow Street on 16 November. Sir Chartres Biron had ordered that all copies of *The Well of Loneliness* were to be destroyed. According to *The Argus*, the

book's publishers, Jonathan Cape Ltd. of Bedford Square and Mr Leopold B. Hill of Great Russell Street, representative of the Pegasus Press, Paris, also appeared at Bow Street to show why the novel should not be destroyed on grounds of obscenity.

Counsel read passages from the book, stating that obscenity should be judged in accordance with the law. He asked the court to say the book was obscene and should be destroyed. Mr Melville KC for the appellants disagreed. The book was a novel, '. . . a true work of literature and not a pornographic production'. But Sir Robert Wallace held up the original order; the book was '. . . a disgusting book, an obscene book, a dangerous and corrupting book'. Although Marguerite Radclyffe Hall mentioned to a Press Association reporter that she wanted to continue to appeal, counsel insisted that no further appeal was possible.

Tragically, *The Well of Loneliness* was forfeited and not published again for twenty-one years, six years after the author's death in 1949.

A GESTURE OF AUTONOMY

Sheila Rowbotham in *A Century of Women* (1997) says, 'The novel contributed to the emergence of a specific kind of lesbian identity.' At the time when Marguerite Radclyffe Hall and her partner, Una Troubridge became lovers, Marguerite had her hair cut in an Eton crop. This was the fashion at the time so she merged into the mainstream. When longer hair later became the vogue, the tailored clothes worn by the lovers and Marguerite's haircut helped them stand out from the crowd. Later, Marguerite, or 'John', persisted with her masculine style, a gesture of autonomy, while Una cultivated more of a feminine persona.

Marguerite Radclyffe Hall lived in Rye from 1930 to 1939, and travelled often to France and Italy to be with another lover, Evguenia Souline. She died in London of cancer in 1943.

5

VIRGINIA WOOLF
A BATTLE OF CHOICES

Modernist literary icon Virginia Woolf (1882-1941) stayed as a child at 9 St Aubyns in Hove. Woolf was introduced to Vita Sackville-West in 1923 and the two became lovers. (According to www.gay.brighton.co.uk, Vita had lived at her mother's home in Brighton at 39-40a Sussex Square in 1919, during her 'scandalous affair' with another partner, Violet Trefusis. Apparently Virginia Woolf found out Violet was engaged to be married when she bought a newspaper at Brighton Station.)

In her biography, *Woman of Letters – A Life of Virginia Woolf*, author Phyllis Rose says, 'Her pleasures in life were almost all to come from being a mind, her miseries from having that mind housed in a body.' The author comments how strange it was that such an independent woman decided to marry but explains that, as a young woman, Virginia Woolf was not particularly daring and wanted the usual things women want from marriage: status, security and stability. The following account from the book gives an extra insight into the writer's personality.

Virginia Woolf is describing an incident in 1908, when homosexual writer and critic, Lytton Strachey entered the room where she and her sister Vanessa were sitting. (Like the Woolfs, Strachey was a member of the Bloomsbury Group.) 'The long and sinister figure pointed his finger at a stain on Vanessa's dress. "Semen?" he said. Can one really say it? I thought and burst out laughing. With that word all barriers of reticence went down . . . sex seemed to permeate our conversation. The word bugger was never far from our lips . . . how reticent, how reserved we had been and for how long.'

It's claimed that Vita Sackville-West had considerably more lesbian experience than Virginia Woolf, and she marked an X in her diary whenever the two had made love. Virginia Woolf's novel *Orlando*, published in 1928, has been described as a love-letter to Vita and includes pictures of Vita dressed as Orlando. Virginia Woolf and Vita Sackville-West often met at the Marlborough Hotel in the 1920s, where the women felt comfortable in conducting their affair and Woolf spent time in the hotel writing *Orlando*, which appeared the same year as Radclyffe Hall's *The Well of Loneliness*. 'However, in *Orlando*, androgyny and transvestism become a cover for lesbian relationships,' says Nicki Hastie, '. . . it appears sometimes as though Orlando belongs really to neither sex.'

OCTAVIA WILBERFORCE

Another of Virginia Woolf's connections with Brighton was through her doctor, Octavia Wilberforce, who practised in Montpelier Crescent, against the wishes of her family

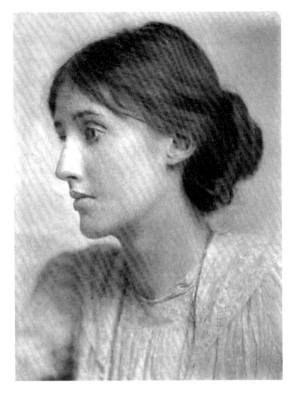

Virginia Woolf.

who would have preferred her to marry well. A descendent of the anti-slave campaigner, William Wilberforce, Octavia lived with her partner, Elizabeth Robbins.

Virginia Woolf's husband, Leonard, became increasingly anxious about his wife's psychological health in 1941, convinced her current mental state was even worse than it was in August 1913 when she'd had a complete mental breakdown and attempted suicide. Leonard decided it would be best to consult Octavia Wilberforce. In March that year, Virginia visited Octavia in Montpelier Crescent and had a long talk with her. Afterwards Octavia and Leonard discussed what was the best course of action to help her. They decided Virginia would find the constant surveillance of trained nurses – or even of Leonard himself – intolerable. But the decision was a difficult one. In hindsight, Leonard later felt the decision he and Octavia took was not for the best.

BREAKDOWN

After fighting the severe breakdowns and mental illness originally brought about by family bereavements and exacerbated by criticism of her failing abilities, Woolf drowned herself in the River Ouse near her Sussex Home, Monk's House, near Lewes, on 28 March 1941. She left a suicide note to her husband Leonard, explaining her gratitude to him and her regret for what she felt she must do. She was cremated in Brighton and her ashes were scattered beneath an elm at Monk's House.

Two of her famous novels were *Mrs Dalloway* (1925) and *To the Lighthouse* (1927).

6

OUTSPOKEN AND OUTRAGEOUS

The following two writers also managed to shock their contemporaries, one for being 'amoral' and the other for sometimes being ingenuously saucy.

BRIGHTON WRITER LABELLED 'AMORAL'

Ivy Compton-Burnett (1884-1969) was born in Pinner, but her doctor father moved his large family to Hove in 1891. (Compton-Burnett had twelve brothers and sisters.) The doctor felt that the Brighton air would be good for the children. At first they lived at 30 First Avenue and then in 1897, they moved to 20 The Drive. Ivy Compton-Burnett had a tragic early life, as one of her brothers became ill and died, another was killed in the First World War and her two youngest sisters committed suicide together.

Unfortunately, Ivy Compton-Burnett was not impressed with Hove, and Brighton fared no better. In her biography, *Ivy, The Life of I. Compton-Burnett*, Hilary Spurling says, 'Ivy detested Hove to the end of her life and steadfastly refused to visit friends who lived in Brighton. "It's a horrid, horrid place," she said . . .'

It was only after moving to London in 1914 that, five years later and in middle-age, she met the writer Margaret Jourdain. In her biography, Hilary Spurling describes Margaret as belonging to: 'the genre of New Woman . . . a small but growing band of unattached, self-assured, purposeful spinsters accustomed to make their own way in the world.' Margaret wrote what Ivy would describe as 'serious books'. The biography tells of an account by a new acquaintance, James Lee-Milne, in 1942. 'Margaret Jourdain is patently jealous of Ivy Compton-Burnett, whom she keeps unapproachable except through herself, and even when approached, guards with anxious care.' The two women remained together until Margaret's death in 1951.

Ivy Compton-Burnett wrote twenty novels, some with an underlying homosexual theme, exposing her to accusations of being 'amoral'. It's claimed in Appendix Two of Hilary Spurling's biography *Ivy* that the author drew heavily on characters from real life, simply transferring directly from fact to fiction. In 1955, Ivy Compton-Burnett received the James Tait Black Memorial Prize for her novel, *Mother and Son*, awarded annually by the University of Edinburgh, and she became a Companion of the Royal Society of Literature and was awarded the DBE in 1967. Other notable novels were *Pastors and Masters*, published in 1925 and *Manservant and Maidservant* in 1947.

BRIGHTON'S MRS MALAPROP

Clemence Dane (1888-1965) was the pseudonym of Winifred Ashton, playwright and novelist. Born in Blackheath in London, her writing name derives from St Clement Dane's church. Previously, she was a painter, then an actress and also a French teacher, before putting all that experience into writing.

The Moon is Feminine is a novel with a rather bizarre plot involving a bachelor, a spinster and a 'sea gypsy', which contained strands of gay, transgender and bisexual issues – and was extremely bold for its day. Also, as author, Rose Collis says, it has 'the worst sex scene ever written by anyone.' Clemence Dane wrote the book at 11 Marine Parade, the present-day site of The Amsterdam.

Clemence Dane helped at the Brighton Gay Switchboard for a number of years. She was endearingly known for her malapropisms, innocently calling herself 'randy' when she meant she was inspired with creative energy. The broadcaster and columnist Arthur Marshall (1910-1989), in his book *Life's Rich Pageant*, published by Hamish Hamilton (1984) described an exchange between Clemence Dane and Noel Coward. She invited him to lunch during the war, a time when decent food was harder to come by. 'Do come,' she told him. 'I've got such a lovely cock.'

I do wish you'd call it a hen,' said Noel Coward.

7

THE POWER OF BELIEF

To empathise fully with the practical and psychological obstacles that confronted early gay and lesbian writers, it might be helpful to go back in time a century or two. Information on Brighton is sketchy for the seventeenth and eighteenth centuries. I've resorted, therefore, to using generic material for this period, to help inform the content of this book.

In the seventeenth century, it was believed that homosexuality was a sin against God, the most serious sexual sin anyone could commit and therefore punishable by death. It was a great temptation for all men and only sustained hard work could effect a cure, leaving the nobility, in their idleness and aimlessness, most vulnerable to indulging their 'baser sexual urges'. The term 'rake' was coined at this time; aristocrats who sought not only women but youths as well. Many books and plays depicted rakes as homosexuals.

Towards the end of the century, homosexual men were displaying more feminine characteristics and around 1690, the first molly houses (male brothels) were being raided. There were a number of prosecutions in 1699, followed by a further wave of raids in 1707. Many of the mollies killed themselves rather than face trial.

LET US NEVER INDULGE . . .

The papers still available from the 1700s are full of religious tracts warning against the consequences of 'sin'. The following example is a short extract from a 'hellfire and brimstone' sermon published in the *Sussex Weekly Advertiser*, dated 22 July 1782:

> Though the body is to be laid down in the earth at our death and not to be raised up till the general resurrection, the soul is never to be in a state of insensibility, but is immediately, after the death of the body, to enter into a state of eternal happiness or misery forever . . . Let us then never indulge our bodily humour and passions and act like tygers and lions and brute beasts that have no understanding.

On 5 August 1782, a letter of response was published praising this religious message and condemning those who 'give a loose to all their inclinations and indulge themselves to the full, wallowing in all manner of vice and wickedness.'

EIGHTEENTH-CENTURY SAFE SEX

Lesbianism was dangerous for all lower-class single women in earlier centuries. In *Women in Early Modern England 1550-1720* by Sarah Mendelson and Patricia

Crawford, the social and moral climate of the 1700s is summarised as follows: 'While contemporaries disapproved of illicit sexual activity by single men, there was a *de facto* tolerance of brothels and prostitution. The only 'safe' sex for single women ('safe' in that it carried no risk of pregnancy) was lesbianism, although all-female households were regarded with suspicion. Even here, there was an integral double standard. Higher status lesbians were able to cohabit with little or no interference, but those of lower status were far more likely to be prosecuted under the Statute of Artificers.'

Today we know little about women, married or single, whose sexual needs were met by other women, in comparison with male homosexuality. Cohabitation was difficult for single women unless one partner disguised herself as a man. Lesbian women therefore disguised themselves by cross-dressing, a practice that could also be an erotic turn-on for same-sex lovers.

8

THE MOLLY HOUSES

In the early part of the eighteenth century, spies were used to search out and close molly houses, which were ale houses used as meeting places for homosexuals, although it would be some time before the word 'homosexual' came into common usage. 'Molly' was a derogatory word to describe a homosexual man, and is derived from the Latin word *mollis* meaning 'soft'. Formerly this word had been used for female prostitutes.

The spies were organised by Societies for the Reformation of Manners and can appear unnervingly similar to the actions of police just fifty years ago. (In a report in *The Brighton and Hove Herald* of 11 March 1961, the setting up of an 'easy nick' was arranged when two policemen hid in a cupboard in a public convenience in Brighton to catch homosexual men. The men were driven to seek partners by this clandestine method rather than being compromised in the regular police raids on local meeting places.)

The molly house provided a large room where mainly working-class men could dance, drink and have fun, and there were private rooms behind, where men could go for sex. There was cross-dressing and some of the men adopted female names, many of them highly exotic. This effeminacy was in stark contrast to the masculine rakes of the previous century. It's claimed that, during the 1700s, about twenty molly houses were closed down.

The author is indebted to Rictor Norton (ed.) for permission to use information from 'The Mollies Club, 1709-10', *Homosexuality in Eighteenth-Century England: A Sourcebook*. The original source of this material is 'Of the Mollies Club', Chapter XXV of Edward Ward's *Satyrical Reflections on Clubs*, first published in 1709.

Edward Ward describes the ceremonies of the molly clubs, and Mr Norton emphasises that the mock lying-in ceremony, when a man pretended to be a woman giving birth, was merely a gay folk ritual and, much later in 1810, several men were arrested in the act of performing such a ritual. 'The cross-dressing and lying-in rituals that Ward describes took place at specific times called "Festival Nights". They were almost always associated with masquerade festivals, representing some kind of survival of folk rituals.' Although the lyings-in were only held at festivals, probably around the end of December each year, the men mimicked women at all their gatherings, dressing like women, gossiping, exchanging feminine confidences and lewd talk.

ROLE-PLAY IN THE BRANDY SHOP

Edward Ward tells how nine gay men were arrested at a gay man's brandy shop, used as a regular meeting place. He describes these men 'who fancied themselves to be women'

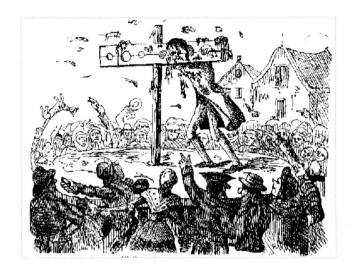

An example showing an unfortunate man being pilloried and pelted to death in 1732. The Newgate Calendar.

and 'fall into all the impertinent Tittle Tattle that a merry Society of good Wives can be subject to, when they have laid aside their modesty for the Delights of the Bottle.'

The men called themselves Sisters, and for the lying-in, one would wear a night-gown to give birth, attended by 'a very officious Nurse', and when the wooden 'joynted Babie' was born, the midwife would dress the baby and the men would carry out the Holy Sacrament of Baptism. Then the men would relax into their roles, tattling about their children, their genius and wit. One would be extolling the 'Vertues of her Husband', and declare he was 'a Man of that Affable, Kind, and easie Temper, and so avers'd to Jealousie, that she believ'd were he to see another Man in Bed with her he would be so far from thinking her an ill Woman . . .' Another would be telling what a 'forward Baggage her Daughter *Nancy* was'. Yet another would be wishing 'no Woman to Marry a Drunken Husband, for her sake, for all the Satisfaction she found in Bed with him, was to creep as close to the Wall as she could to avoid his Tobacco Breath and unsavoury Belches'. And so on.

Ward concluded with his belief that this effeminate gossip was meant to extinguish the natural affection due to women. After all this, the usual activities of the molly house would resume – that is, until the Reforming Society gathered strength and managed to put an end to their 'scandalous Revels'.

MOTHER CLAP'S

In 1726, after a tip-off, there was a raid on Mother Clap's, a famous molly house in Holborn, London. The woman who ran it, Margaret Clap, was sentenced to the stocks.

Local people savagely assaulted the unfortunate woman while she was in the stocks and it's believed she died shortly after from her injuries, although there is no written record. What is known is that sentencing to the stocks was a most cruel punishment; people had their bare feet whipped, a practice known as *bastinado*, and this was excruciatingly painful due to the cluster of nerve endings in the soles of the feet. Those subjected to the stocks were often left for days in all weathers and many died from heat

and exhaustion. Sometimes, those who were dragged back to jail were so covered in filth as to be unrecognisable. Men who were caught on Mother Clap's premises were hanged at Tyburn on 9 May 1726.

A WHIPPING FOR A SOLDIER

In this climate, even the smallest transgression brought about a heavy punishment as the following early example of 'euphemism' shows: 'Two troops of the 10th regiment of dragoons marched into quarters in this town to remain for the summer' reported *The Sussex Weekly Advertiser* of 15 July 1782. (The 'town' was the East Sussex capital, Lewes). The following day, one of the men appeared before a court martial for 'misbehaving in his quarters'. The man was sentenced to a whipping, which was inflicted on him early the next morning.

9

TWO PROMINENT COURT CASES OF 1835

The 'invasion' of Brighton began with Dr Richard Russell's now famous thesis, *A Dissertation Concerning the Use of Sea Water in Diseases of the Glands* in the 1750s, when people flocked here in search of a cure for their ills. Then, in the 1770s, the Prince Regent used Brighton as an escape from the rigours of London life and built the Royal Pavilion for his own pleasure and relaxation. The Prince's liking for a bohemian lifestyle provided an invitation for freethinking individuals and this invasion of fun-seekers was later intensified due to the advent of the railways in the mid-1800s. Although full reports of court cases against homosexuals were uncommon in the nineteenth century due to their suppression, the following two cases, both of which were tried in 1835, were sufficiently high profile to warrant fairly detailed accounts.

JOHN SPARSHOTT – DIGNITY UNDER DURESS

A nineteen-year-old Brighton man was the last convicted of homosexuality to receive the death sentence. *The Brighton Patriot* of 25 August 1835 reported the execution at Horsham of John Sparshott the previous Saturday. The young man was hanged together with thirty-three-year-old Richard Sheppard who had committed four burglaries in Brighton. The Victorian newspaper stuck to its usual policy of euphemism, and after describing Sheppard's wrongdoings, added that John Sparshott had been found guilty of 'an abominable offence.'

John Sparshott had been tried at the previous Assizes on the same day as Richard Sheppard. The article in *The Brighton Patriot* emphasised the dignity displayed by both men on the day they were executed. Preparations began in the early hours of the morning for carrying out the sentence and the erection of the drop. At eleven o'clock, the men attended chapel in the presence of the other prisoners, where the Revd Mr Torbutt, chaplain, administered the last sacrament. As the clock ticked forward to midday, the men were passed over to the sheriff. The newspaper report said they appeared resigned to their fate and were praying fervently. When they were pinioned, they fell to their knees, continuing to pray, oblivious of their surroundings.

The procession then ascended the stairs to the scaffold, the two men still praying with the chaplain. First, Richard Sheppard appeared on the platform, with John Sparshott close behind him, 'both exhibiting the same fortitude and penitence as marked their conduct from the beginning,' said the paper. 'The drop fell and they were launched into eternity and died without a struggle.' When the men were taken down, their friends

took the bodies, which were placed in coffins covered with a black cloth. Three-hundred people attended the execution and the paper remarked this was fewer than usual.

SCANT INFORMATION AND INCORRECT NAMES

The newspaper entry on John Sparshott's case at the Sussex Summer Assizes on 11 August 1835 had warranted a single sentence. *The Brighton Patriot* didn't even get his name right. 'John Shakall', aged nineteen, was convicted of an unnatural crime and sentence of death was passed on him. The paper specified that the accounts concluded trials from the previous week. In the earlier edition, 4 August 1935, the offence had been detailed along with that of Richard Sheppard's much longer entry, the latter warranting seventeen lines. Confusingly, John Sparshott's case read: 'The Nisi Prius Court has been engaged all the morning with the case The King v. Huggins. The details were very disgusting. The Judge, without summing up, directed the jury to find a verdict for the defendant.'

'Sparshott' and 'Huggins' are definitely one and the same; there was no other 'crime' of this nature reported at that time and the report appeared along with Sheppard's case on the specific date mentioned of 11 August 1935. Perhaps Sparshott gave a false name, or the reporter may have been mistaken, or maybe it was considered prudent to withhold the identity of the prisoner at this early stage of the proceedings, but this is only speculation. John Sparshott was the last man in the country to be executed for homosexuality.

STANLEY STOKES' SUICIDE IN EAST STREET

An article appeared in *The Brighton Patriot* on 24 May 1835 regarding the suicide of Stanley Stokes, and the inquest was reported the following week on 31 May 1835. The following summary includes information from both reports and an additional short piece in the 31 May 1835 edition of the paper.

On Saturday 21 May at around ten o'clock, Stanley Stokes killed himself in East Street by cutting his throat with a penknife. 'The loss of blood was frightful,' said the article, 'and assistance does not seem to have been rendered very promptly.' Stanley Stokes died the following Monday at the County Hospital and the paper recorded that the event had caused a great sensation in the town, although there was much commiseration for the man's family.

Stanley Stokes had left his family and travelled to Brighton, taking lodgings with Mrs Troubridge in East Street where he had stayed before. While in Brighton, he made improper proposals to a groom. The first article told how the groom's friends urged him to go with Stanley Stokes for a walk on the Chain Pier that evening. While the two were walking, and at a signal, the others broke in, tarred Mr Stokes over the face and tore his clothes. They tried to take him to the town hall, but he cut his own throat with his penknife.

Mr Stokes was the Proctor in Doctors' Commons (a solicitor belonging to a society of lawyers practising civil law in London.) Evidence was given to the court about the suicide, describing how, after Mr Stokes had cut his throat, he had to be held up around

the waist by an eyewitness, a baker named William Cornford. Twelve-year-old Frederick Riddlestorffer also witnessed the mutilation and told the court he was so frightened by the sight that he ran indoors. The baker was in the hatter's shop and was alerted by a cry of 'Stop him! Stop him!' He said the man was 'genteelly dressed'.

Stanley Stokes was taken to the town hall, arriving at about 9.50 a.m. on Saturday morning, said Nat Hayer Lindfield, a policeman, who described how other policemen ran out to find the deceased 'streaming with blood, supported by Cornford'. It was three quarters of an hour before Mr Stokes was taken to the county hospital. In St James's Street, he was worried about his watch, and was told it was in the possession of Mr Solomon, a policeman.

James Saunders, landlord of the New Ship, said he saw people gathered together in the area and was told the gentleman was improperly accosting a groom. Mr Stokes had been seen loitering around Black Lion Street and the corner of Ship Street. Mr Saunders told the groom, Richard Stokeley, to go home. Stokeley, who worked for Mrs Page of King's Road, said, 'I can't go home. The man is waiting for me.' Then Richard Stokeley explained how he and Stokes had walked to the roundhouse where they stopped. After some time, a Mr Ridley and Mr James Saunders approached them. Mr Ridley talked of sending for an officer. Stokes said, 'For God Almighty's sake, don't send me to the Black Hole [prison cell] and expose me.'

A juror asked Richard Stokeley whether he went to meet Mr Stokes by appointment and the judge asked 'Why did you go east when your home was westward?' The groom said he wanted to go home but the man would not let him. The inquest report seems to conflict with the earlier report. This had stated that the groom met Stokes by appointment and the two were 'broken in on' while on their walk, resulting in the tarring of the deceased. Richard Stokeley did not give a direct answer and the court did not appear, from the newspaper report, to establish this point.

A surgeon, John Seabrook, said that in his judgement the wound was not the occasion of his death (even though it was 5 inches long). He was 'labouring under great cerebral affection . . . great mental excitement which alone or in connection with the wound would have occasioned death'. Usual remedies had been applied but Stanley Stokes died on the Monday.

Mr Somers Clarke acted for the deceased man's family. He brought Mrs Ann Troubridge, the deceased's landlady, to give evidence showing his behaviour should be attributed to derangement of intellect. 'This would be an act of justice to the feelings of the survivors,' said Mr Somers Clarke. Mrs Troubridge explained Mr Stokes was in Brighton to recover from the upset of his wife's grief for a baby who had died three years ago. According to the newspaper, the verdict – that the deceased, while labouring under cerebral affection and temporary derangement, inflicted a wound on his throat from the combined efforts of which he died – was intended to ease the grief of Stokes' family.

10

'MORALITY' IN VICTORIAN BRIGHTON

In the middle of the nineteenth century, with the railway link between London and Brighton in operation, the floodgates opened and the town became accessible for day-trippers and holidaymakers. Soon, a lively community of diverse people settled around the area of the seafront and south lanes, beguiled by Brighton's modern, buzzy atmosphere. In 1845, Princess Victoria was horrified at the goings-on and, after being jostled by street-traders, Her Majesty took off from the Royal Pavilion in high dudgeon, back to London, refusing to visit again for twenty years. Kemp Town, the original idea of Thomas Kemp, was completed around 1855.

STIFF UPPER LIP

To our modern minds, the Victorian era may appear to be an alien world. After all, this was a time when some people covered their piano legs for fear of arousing dangerous passions. Yet it was a two-tier system. Anthropologists say that it is usual in most human societies for a discrepancy to exist between moral codes and actual human sexual activity, as explained by Michael Mason in his book *The Making of Victorian Sexuality* (1994).

> But the orthodox picture of Victorian hypocrisy is more extreme and this is truly odd. According to the picture, assenting to the public code was a matter of conscience, and often reluctant lip-service, with actual behaviour being guided by a fully-formed alternative standard . . . There is something preposterous about the degree of self-inflicted discomfort with which the Victorians are often supposed to have endured.

Due to Victorian prudery, throughout most of the nineteenth century, details of trials of men convicted of homosexuality only received full exposure in the press if there was some other issue involved, for example, blackmail or murder.

A NURSERY FOR LOOSE AND DEGRADED HABITS

Vagrancy was a problem in Brighton as elsewhere, due to poverty and lack of education. *The Brighton Herald* published an article on 11 February 1854 based on a report compiled by the inspector of the Brighton and Hove Philanthropic and Juvenile Street Orderly Society describing how only two out of eighty-six vagrants were genuinely destitute. 'There is little doubt that Brighton, from the number of its wealthier residents

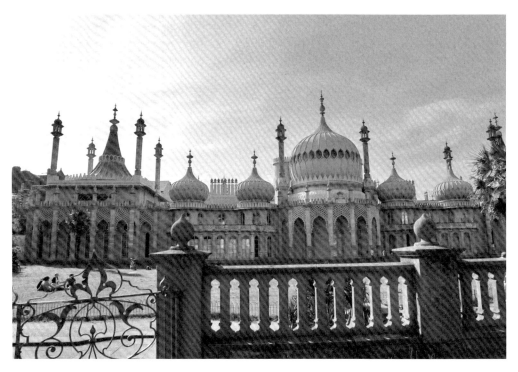

The Royal Pavilion. (© Gareth Cameron)

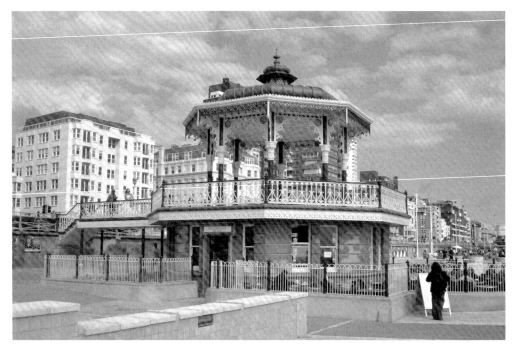

The Brighton Bandstand, also called 'The Birdcage' has recently been restored to its former Victorian splendour. (© Janet Cameron)

and visitors, attracts more than its fair share of vagrants.' The majority of vagrants were idle, abandoned and worthless characters who begged as a profession and Brighton was a nursery for loose and degraded habits; for vice, immorality and crime.

The article also revealed that fifty of the vagrants were poor and could not read or write – but it seemed that was no excuse.

THE FAIR ON THE LEVEL! WHATEVER NEXT?

A fair was held at The Level in Victorian times and was a source of dissent. A rather pompous letter was written to *The Brighton Herald*, dated 6 May 1854, taking the commissioners to task for setting up a committee to make the arrangements for the next fair to be held on the 18th of the month.

'But why, I beg to ask,' says the writer, 'should the inhabitants of the north part of the town be subjected to this nuisance? Why should the Commissioners sanction the scenes of riot, debauchery and intoxication that always take place on these occasions? Does this town derive any benefits from these Fairs? Who do they draw into the town? The lowest of the low, the Gypsy, the vagrant and the thief.'

The writer thunders on for a few more lines, then suggests that many people of both sexes can trace their ruin to these fair-nights. He cites the firing of pistols, the beating of gongs and the playing of 'Pop Goes the Weasel'. Further annoyances were drunken shouts, quarrelling and fearfully disgusting language, in short, it was a disgrace to the town. He finishes, 'I am, Sir, AN INHABITANT OF THE NORTH PART OF THE TOWN.'

ABSENCE OF SEXUALITY IN WOMEN

Dr William Acton published a medical reference book, *The Functions and Disorders of the Reproductive Organs*, in 1857. It contains many warnings about the dire consequences of masturbation and impure thoughts: 'In a quarter of an hour a person may entertain a thousand bad thoughts; every one of them to which he consents deserves a hell for itself.'

As for female sexuality, Dr Acton says: 'The majority of women, happily for them, are not very much troubled with sexual feelings of any kind.' The chapter in which this strange assertion appeared was about impotence in men, and intended to reassure them it was still acceptable to marry – since the women wouldn't mind!

S & M VICTORIAN-STYLE

Despite Victorian prudery, alternative sexual desires could be satisfied if you knew where to look. The following applies equally to heterosexual interests, but is another example of the Victorian double standard. A book was in private circulation in 1885 to titillate and satisfy secret fantasies. Instances of whipping inflicted on both sexes appeared within its covers with 'curious anecdotes of ladies fond of administering the birch'. The book was claimed to be compiled by an 'amateur flagellant'. It was sold as a package with two riding crops and a wooden handled cat o' nine tails.

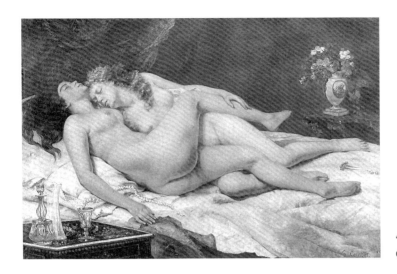

'Le Sommeil' (Sleep),
Gustave Courbet, 1866.

The risqué publication was much later offered for sale at a Lewes auction in spring 1993, as reported in *The Evening Argus*, dated 6 March 1993. The auction house, Wallis & Wallis expressed their dismay when made aware of its contents, which were felt to be offensive! 'The book will now be returned to its owner. After all, it's his property,' said a spokesperson.

CROSS-DRESSING *C.* 1886

The Sussex Weekly Advertiser, dated 8 March 1886, carried 'an extraordinary story' of cross-dressing. A family employed a lady's maid, but several items, for example, plates and jewellery, had mysteriously gone missing. The thefts were reported to Scotland Yard and a detective was sent to investigate. After he was acquainted with the facts, the detective became suspicious of the lady's maid and, believing she was the culprit, he suggested the lady of the house should leave her handkerchief in the room and send in the maid for it. When the maid entered the room, the officer questioned her.

The detective arrested the lady's maid – but on another charge. He recognised her face from a photograph in his possession as a wanted criminal. But there was a twist. The detective knew that the prisoner he was conveying to London was actually a man masquerading as a lady's maid. No one in the house had suspected the maid was a man. It's not stated in the report whether the lady's maid was a genuine cross-dresser or whether this was just a useful disguise for a felon needing both a job and a disguise. It was claimed that the butler had been walking 'her' out as his sweetheart, but the paper added it wasn't sure about the veracity of this claim.

DEATH PENALTY

Penetrative homosexual acts by men were punishable by the death penalty until 1861. On 9 July 1860, John Spencer, aged sixty, was found guilty after three trials, and he

received the death penalty but the sentence was commuted. In reality, few men were executed for this 'crime' since proof that the act had been committed required two eyewitnesses and proof of penetration and ejaculation.

THE CRIMINAL LAW AMENDMENT ACT

Due to the difficulty of obtaining conclusive proof of penetrative homosexuality, the parameters for conviction were widened to 'assault with sodomitical intent' and shortly after, the Criminal Law Amendment Act of 1885 prohibited 'gross indecency' between consenting male adults with a punishment of two years' hard labour. The Act was originally intended to address the protection of women and girls and the suppression of brothels. Now it also pronounced on the practice of homosexuality with a lower requirement of proof, so that all homosexual male activity was criminalised without any dependence upon proof of penetration, leading to a more intense and far-reaching homosexual sense of identity.

The Labouchere Amendment, named after Henry Labouchere who introduced it, was passed on 7 August 1885 and reduced the sentence to two years' imprisonment with hard labour. The amendment became known as 'The Blackmailer's Charter'. The 'indecent relations' prohibition remained until 1967, as did the law against homosexual intercourse, which still carried a maximum sentence of life imprisonment. Since Queen Victoria had pronounced 'No woman would do that!', the Act did not extend to women. Victoria would probably be in full agreement with Lady Greville's sentiments – see below.

A VICTORIAN LADY'S CONTEMPT FOR 'MANNISH' WOMEN

An article appeared in *The Argus*, dated 19 June 1895, entitled 'Women Past or Present'. Its subject was a scathing comparison of the (then) modern-day women with 'our grandmothers'. Lady Greville said she had great contempt for the 'mannish' woman.

> Many women have wished they had been born men, with man's physique, his independence, his strengths, his advantages and capabilities, but surely no sensible woman could wish to resemble an emasculated man, or what is commonly called a masculine female? To be advanced nowadays means to have thrown every shred of femininity to the wind, to ignore tradition, heredity, all the teachings of science and most of the lessons of experience.

Much of the article focuses on the academic excellence of women past. At least, the excellence of those few sufficiently privileged to gain access to money and education, although, predictably, Lady Greville ignores this disparity. Instead, she asserts that women's rebellion in the present day was found in the *sturm and drang*[1] of life. This sent women into the world to make their livings; in the competition, women, being the weaker, 'went to the wall'.

1. *Sturm and drang* means 'storm and impulse'. This was a German movement in literature and music from 1760 to 1780 in favour of free expression of emotion, thus countering the rationalism of the Enlightenment.

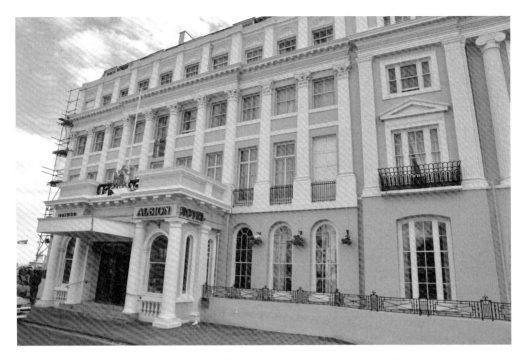

The Royal Albion Hotel, where Angela Burdett-Coutts stayed with her lover, Hannah.
(© Gareth Cameron)

'The bicycle-riding, divided skirt, short-haired, cigarette-smoking females of today may feel themselves immensely free and congratulate themselves on their immunity from the shackles of conventionality, but is their triumph so great, is it not easily discounted when we sit down soberly and ask what it has gained in the sum of human happiness?' Then Lady Greville emphasised the 'disabilities of women including stays and tears' which, she said, could not be discarded so lightly, leaving only cynicism, unreality, revolt and discontent.

AN UNCONVENTIONAL AND 'MANNISH' GREAT PHILANTHROPIST

Angela Burdett-Coutts (1814-1906), who is claimed to have been the wealthiest woman in England, was responsible for founding the NSPCC and was a co-founder of the RSPCA. According to *Brighton Ourstory*, she stayed in Brighton at The Royal Albion Hotel with her lover and partner, Hannah, and the women are said to have loved the theatre, frequently visiting The Marlborough, where they enjoyed the company of like-minded women in the bar. Angela Burdett-Coutts was said to be utterly devastated when Hannah, 'my poor darling', died in 1878. Later, at sixty-seven, she married her young secretary, an M.P. of twenty-seven years, William Bartlett. It's interesting to speculate how her contemporary, the huffy Lady Greville, above, would have reconciled Angela Burdett-Coutt's great philanthropic deeds with her confident disregard for the conventions of the day.

MISS ELPHINSTONE-DICK

Another notable Brighton character at this time was Harriett Rowell, also known as Miss Elphinstone-Dick, (1858-1902) who taught swimming at Brills Baths in the 1870s. She swam in a rough sea from Shoreham to Brighton in 2 hours 43 minutes. Her lover was Alice Moon and the couple emigrated to Australia where they lived in the Melbourne suburb of Brighton. In 1879, they opened and ran a gym together. Miss Elphinstone-Dick died in 1902 in Brighton, England.

11

WHITE SOCKS AND BATTLEAXES

The avant-garde, artists, musicians, performers and writers continued to flock to Brighton. During the homophobic early 1900s, gay men wore white socks to signal their sexual orientation. Gradually, with the growth of Brighton's tourist industry, the area closest to the coast was developed and hotels, guest-houses and other attractions sprang up to accommodate this influx of visitors. Gradually, the homosexual community started to move further east, to the north lanes and into Kemp Town. Now St James's Street and Old Steine provide the hub of the LGBT community with their gay-friendly bars and venues.

Women's suffrage and lesbian issues were inextricably linked at this time in the struggle for equality. An article in *The Observer* by Vanessa Thorpe and Alec Marsh, dated 11 June 2000, reports how the diaries of suffragist Mary Blathwayt reveal that key members of the Votes for Women movement led lesbian lifestyles. According to the diaries, Mrs Pankhurst and Ethel Smyth often shared a cell together when confined in Holloway Prison.

In 1909, Marian Wallace Dunlop went on hunger strike while in jail and was force-fed, a horrible process involving gags and tubes. Soon, other suffragettes were subjected to this humiliation, leading to the Prisoners' Temporary Discharge for Health Bill in 1913. This was known as the 'Cat and Mouse Act' because it released them to recover, only to arrest them again when they were well.

In the 1920s, in the wake of the First World War, people were singing feel-good songs like 'Good Times are round the Corner', 'Sing as you Go', and 'Happy Times are Here Again'. Although Brighton began to prosper, it was a far from happy time for everyone – homophobia was rife and homosexual men would continue to be persecuted by the law for at least another forty or fifty years. Consequently, their professional and social lives could be devastated by exposure or blackmail. Some resorted to heterosexual marriage to protect themselves and their careers from abuse. Matters did not begin to improve until around the 1970s.

AN ANONYMOUS LETTER

Women, whether heterosexual or lesbian, were still undermined not only by the patriarchal society, but also by a more insidious faction, the female 'fifth columnists', whose vociferousness and determination in protecting the status quo makes uncomfortable reading today. The following report echoes that of Lady Greville back in the previous century.

'That Monstrous Regiment of Women' was the heading for a letter to *The Brighton and Hove Herald* on 30 September 1933. It came in the wake of the appointment of a woman mayor for the town, Miss Margaret Hardy, MBE. Miss Hardy was due to take up her appointment on 9 November that year. The letter was anonymous; the writer had merely signed herself N.G.

> To the Men of Brighton:
> May I ask what the Men of Brighton are thinking about? Must they shift their responsibilities onto a Lady Mayor? Are they all becoming women-ridden? How far have we got to go before we can have with us a type of masculine men over whom woman's love of petty power could not prevail? . . . We can prophesy an increasing degeneracy of life in England that will reach its lowest point with the zenith of feminist influence. This from a woman, not old fashioned, but who sees beyond her nose.

The Brighton and Hove Herald had an enlightened editor who responded: 'Did England decline to its lowest point under Queen Elizabeth – or Queen Victoria?'

But N.G. wasn't finished with *The Herald* just yet. On 14 October 1933, she wrote again and expressed her disappointment that the Men of Brighton had not responded to her letter and wondering if they agreed with her. 'I do not think that anyone can deny that woman's direct influence in most civilisation has been small and that where their direct influence has been felt, it is always unfavourable,' she says. 'Modern society is so thoroughly saturated with feminist prejudices and ideas and the growth of feminism has been so steady and insidious, that thousands of men and women today are feminists without knowing it.'

She concluded that no happiness had been gained, but exactly the reverse, since the influence of women tended to falsify and destroy every natural relation and sound institution in social life.' This time N.G. signed herself Norah G.

LAUGHTER IN COURT

The following report in *The Argus*, dated 2 December 1927, provided some magistrates with amusement regarding the meaning of a word. Mr Mead, an octogenarian magistrate, diagnosed the legal meaning of the word 'indecency'. Indecency, he pointed out, was a very mild word meaning 'unbecoming'. Then he told a story of a noble lord in the House of Lords who remarked that he considered a right revd prelate had pressed on with a second reading of a Bill 'with indecent haste'. On opening his evening paper that night, the right revd prelate was amazed to find the following headline: 'Charge of Indecency against a Bishop.'

Mr H. W. Wilberforce, another minister, commented, 'I gather that on a charge of that kind Mr Mead would have convicted the prelate.' Even in Victorian times, it seems, editors would do whatever they could to sell their newspapers!

THE STAR OF BRUNSWICK – A PERSONAL MEMORY

Ron Forrest tells how, just before the advent of the Second World War, there was a pub called The Star of Brunswick (not to be confused with the present-day Brunswick at the

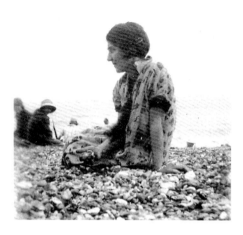

Brighton beach in 1933. (© Janet Cameron)

corner of Holland Road and the seafront) that was situated at the bottom of Little Western Street East, on the corner. Some people came to Brighton from London on bikes whenever there was a bank holiday. Others roared into Brighton in their posh motor cars.

Ron's personal memory is reminiscent of the stories of the molly-house festivals, when the mimicking of lying-in and giving birth was part of an ancient folk ritual, a practice that was repeated in the early nineteenth century and re-enacted at the gay-friendly Star of Brunswick in the 1930s. It was an opportunity to chill out, making a special time for the acting out of secret fantasies. 'They made for the Star of Brunswick, with its regular piano player,' says Ron, 'and the men felt free to perform their special rituals; to dress up as women and sometimes they would carry dolls.'

In the 1920s and '30s, there were great places to go in Brighton for gay men and lesbians, for example, St James Tavern in Madeira Place and the New Pier Tavern, a venue popular with sailors. Then there were tea dances at the Royal Albion Hotel especially for women, providing a good meeting place for lesbian couples.

12

BRIGHTON'S ARTISTS AND MUSICIANS

NO CONTRADICTION BETWEEN RELIGION AND HOMOSEXUAL LOVE

Eric Gill (1882-1940) was a sculptor, printmaker and engraver, born in Brighton on 22 February 1882, the son of a non-conformist minister. He moved to Chichester in 1897, and then in 1904, he married Ethel Hester Moore and the couple moved to Ditchling. Eric Gill was a devoutly religious man and produced many engravings with religious themes. He was also passionate about erotic art and interested in homosexual relationships, apparently finding no contradiction between his two main passions.

His first commission was to carve the fourteen Stations of the Cross at Westminster Cathedral between 1914 and 1918 and his last was the altarpiece for the St George's Chapel at the cathedral (1940). The erotic life drawings in his book *First Nudes* were begun in 1926 and the book contains twenty-four original sketches (see *Eric Gill, The Engravings* by Christopher Skelton, Herbert Press, 1990).

THE NEW VALENTINO

'The secret of the success of the late Ivor Novello is that not only did he give his large public what they wanted but he also believed in it.' So said *The Argus* of 12 February 1952 in a review of Novello's play *King's Rhapsody* at the Hippodrome in Brighton.

Songwriter Ivor Novello (1893-1951) was once celebrated as The New Valentino. In 1916, he met actor Bobbie Andrews and the two men became lovers. Bobbie was given the part of the prime minister in Novello's play *King's Rhapsody* at the Theatre Royal in Drury Lane. Bobbie Andrews also starred in several other plays and musicals written by Ivor Novello. Novello wrote *Glamorous Nights*, his famous show, at The Lanes Hotel in Marine Parade, Brighton and, it is claimed, he got the inspiration for a further hit in 1945, *Perchance to Dream*. Ivor Novello and Bobbie remained together for thirty-five years.

GLUCK – A PAINTER WITH A TROUBLED LOVE-LIFE (1895-1978)

She would only allow herself to be known as Gluck (rhyming with 'duck') and was furious if anyone prefixed her name with a 'Miss'. She chose this form because she felt that the paintings were what mattered, not the gender of the painter, and decided to follow Whistler's example. Her biography, *Gluck* by Diana Souhami, tells how she was to be included on the letterhead of an arts society. 'A graphic designer . . . stuck in an ameliorating Miss.'

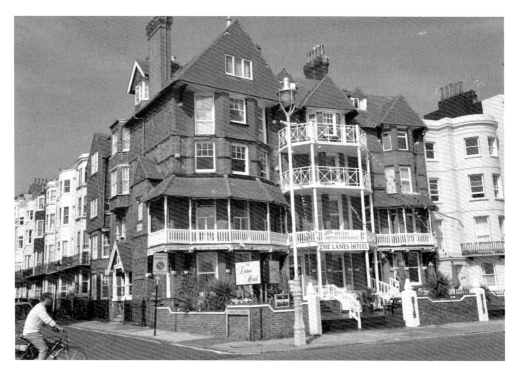

The 'New Valentino', Ivor Novello, stayed at the Lanes Hotel to write a popular show. (© Gareth Cameron)

Immediately, Gluck resigned and insisted on the 'inking out' of her name. She also attempted to sue a publisher who produced a fictional work with a protagonist called 'Glück'.

Born Hannah Gluckstein (1895-1978), with an opera singer for a mother, her two uncles founded the catering establishment, J. Lyons & Co. Diana Souhami tells how Gluck, confident and authoritative, dressed in men's clothes, pulled wine corks and opened doors for ladies. Her private income allowed her to devote all her energies to her work and she was acclaimed for her floral paintings and portraits. Her 'Medallion', a profile portrait of herself and her then-lover, Nesta Obermer, appeared on the Virago publication *The Well of Loneliness* by Marguerite Radclyffe Hall.

Gluck's link with Brighton began in 1944 when she moved to nearby Steyning to live with Edith Shackleton Heald at The Chantry House. She became a regular visitor to Brighton shops, venues and theatres. But it was not an ideal situation. Gluck, Edith and Edith's disapproving sister, Nora, made an awkward *ménage à trois*.

To complicate matters further, Gluck was still in love with Nesta Obermer, her former lover, a woman she regarded as her 'wife', although Nesta was actually married to Seymour Obermer, a much older American, who financed her extravagant lifestyle. Although Nesta professed her love for Gluck, divorce in the 1930s was far from easy and she was not prepared to suffer the scandal, social annihilation and reduced income that would be the result of leaving Seymour for Gluck. Gluck never got over this intense love affair reported to have begun in 1936, at a concert of Mozart's opera *Don Giovanni* at Glyndebourne. She always referred to this period of her life as 'YOUWE'.

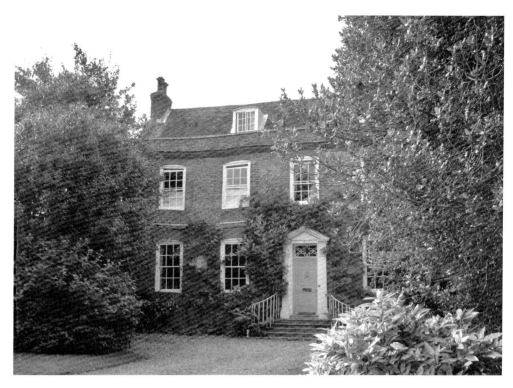

The Chantry House where Gluck lived with Edith Shackleton Heald (© Janet Cameron)

Edith and Nora invited Gluck to live with them and, longing for a real home, she agreed. Edith had been a special correspondent on the *London Evening Standard* and she also wrote for the *Express*, *Sunday Express* and *Daily Sketch*. She had formerly been the lover of William Butler Yeats, the poet, who had stayed at The Chantry House. When Gluck moved in, Yeats had been dead for five years. Nora was a journalist and editor, and was working for *The Lady* when she retired in 1954.

But soon there was friction. Nora was scandalised by the relationship between the two other women. There were petty arguments, rudeness, tears and jealousy. Most of Nora's friends took her side against Gluck, but Edith insisted Gluck should stay. So Nora went straight to bed after supper, and didn't rise until lunchtime. Sometimes she visited her friend Alison Settle just to get out of the house. Meantime, Gluck and Edith enjoyed visiting the Theatre Royal in Brighton to see the latest plays, including Oscar Wilde's *Lady Windermere's Fan*. Edith called Gluck her 'Darling Grub.'

Nora became increasingly agitated, calling Gluck and Edith 'disgusting people' and eventually she moved out of her own house, having been paid half its value from Gluck's 'Trust'. Nora's new home was in Wykeham Terrace in Steyning, and on the day she moved, 14 February 1948, she was sixty-five years old. Gluck later expressed regret that Nora had been forced to move from her own home. Edith died on 4 November 1976 and Gluck died fourteen months later on 10 January 1978, aged eighty-two. Nesta, the greatest love of Gluck's life, outlived her and, when asked if she wanted anything of Gluck's, Nesta replied, 'Oh, a few of her fine-haired brushes.'

13

THE SCANDAL OF THE 'BRIGHTON MARRIAGE'

Lillias Irma Valerie Arkell-Smith lived at the Grand Hotel in Brighton during the 1920s with her lover, Alfrida Haward, where she was known as 'Colonel Victor Barker'. Mrs Arkell-Smith dressed and behaved like a man and was active in the Fascist party. She and Alfrida were married as man and woman, but the deception was exposed in 1929. This is an account of her trial and eventual conviction for perjury. (In some references to this case, the name is spelled 'Elfrida', but 'Alfrida' is used here, in line with its spelling in the 1929 *Argus*.)

The Argus of 24 April 1929 reported the Old Bailey trial under the heading 'Col. Barker Case, Charge of Committing Perjury' and the subheading 'The Brighton Marriage'. At the time, Mrs Arkell-Smith was thirty-three years old and, by now, notorious as the woman who, for several years, lived as a man, Colonel Victor Barker. Charged with perjury, she appeared before the recorder Sir Ernest Wild, KC, the same morning as the report. The case scandalised and titillated the general public and a crowd, mostly fashionably dressed women, gathered seeking entry to the public gallery. When the crowd was admitted to the court, there was a scramble for places and the public gallery was already full by 9.45 a.m.

Mrs Arkell-Smith was defended by Sir Henry Curtis Bennett, KC, and Mr Anthony Hawke, while Mr Percival Clarke conducted the case for the Director of Public Prosecutions. The paper reports that all eyes were turned towards the door to the dock as Mrs Arkell-Smith arrived, describing her as: 'A tall, upstanding figure, with her complexion deeply bronzed, she wore a red coat over a light grey costume and a soft, felt hat was pulled down over her close-cropped hair. In the buttonhole of her coat was a bright red rose.'

The charges were read out to her, the first charged her with committing perjury in an affidavit sworn on 29 June 1928 in an action in the King's Bench Division, and the second was for making a false statement in the marriage register on 14 November 1923.

'I plead not guilty to the first charge and guilty to the second,' she replied. Mr Clarke said that in some respects the charge on which she pleaded guilty was the more serious. The judge gave his approval and the first charge remained on file.

Mr Clarke then set out the details to the court, saying that, in 1922, Mrs Arkell-Smith was passing as Mrs Pearce Crouch. She was originally the wife of an Australian soldier (Lieutenant Harold Arkell-Smith) and had married him in April 1918 in Surrey, but they only lived together for six months. By the end of the war, Mrs Arkell-Smith was running a teashop with a woman friend in Warminster, Wiltshire, when she met Australian soldier Pearce Crouch. The couple lived together as man and wife; she took his name

and had a son and daughter by him. (At the time of the trial, her children were nine and seven years old respectively.)

THE BEGINNING OF THE 'DECEPTION' OF ALFRIDA HAWARD

In 1923, Mrs Arkell-Smith patronised a chemist's shop belonging to a Mr Haward at Littlehampton, and, although still using her husband's name, she dressed as a land-girl in riding breeches, open-necked shirt and coat. She lied to Alfrida, Mr Haward's daughter, saying she was really Sir Victor Barker, Bart, and explained her father had died some years previously. Her unlikely story was that her mother wished she should dress as a woman, but apparently Alfrida believed it. Then Mrs Arkell-Smith proposed marriage to Alfrida, and the illegal ceremony took place at the parish church of Brighton on 14 November, where she entered the false details in the marriage register.

This was the offence to which she pleaded guilty.

DETAILS OF THE MASCULINE 'MASQUERADE'

Mr Clarke set out before the court the deceptions used by the defendant. She claimed to have been a captain in the army and a member of the Distinguished Service Order. The name, rank and title enabled her to secure credit for clothing and, in May 1926, one of the firms to which she was indebted by about £40 brought an action against her. The action was never pursued.

The recorder asked if the women were living together as man and wife from 1923 for around four years, and Mr Clarke confirmed this. He mentioned that, at the beginning of 1927, Captain Victor Barker, DSO, joined the National Fascist Movement and was appointed secretary to one of the principals. A summons in 1927 for an offence against the Firearms Act led to Colonel Barker's prosecution, but eventually the 'Colonel' was acquitted. This was aided by the appearance in court of Colonel Victor Barker with his eyes bandaged while being led into the dock by a friend. It was claimed the Colonel had previously suffered temporary blindness from war wounds and the strain of the court case had brought on the trouble again.

At the recorder's amazed response to this account, Mr Clarke said, 'Not a soul in court – and I think I prosecuted her on that occasion – was aware that it was other than a man in the dock.'

SERIOUS DEBT LEADS TO BANKRUPTCY – AND WORSE

Mr Clarke explained how, in 1928, a widow, Maud Roper Johnson, brought an action against Colonel Victor Barker in the sum of around £300. The prisoner swore an affidavit as Leslie Ivor Gauntlett Bligh Barker, colonel in His Majesty's Army, retired. The paper quoted the following from the affidavit:

I have had experience in the catering and refreshment business. During the war I was in charge of Army canteens and after the war, civilian canteens. During the time I was in

cavalry, I acted as a messing officer to various messes to which I was attached, for about eighteen months.

A bankruptcy order was made against Victor Barker on 13 October 1928. The 'Colonel' did not put in an appearance, so tipstaffs were issued with a warrant for his arrest, which was executed on the following 28 February 1929 at the Regent Palace Hotel. The tipstaffs found the defendant in masculine dress at a reception desk and conveyed him to Brixton Prison. During a routine medical examination, the surprised doctor discovered that Colonel Victor Barker was a woman and she was transferred to a different prison.

She swore another affidavit, now describing herself as Lillias Irma Valerie Arkell-Smith, known as Leslie Ivor Gauntlett Bligh Barker, married woman. The exposure of her lies, said Mr Clarke, showed that the defendant had 'a total disregard for truth or the sanctity of an oath.' He was shocked she had chosen to perpetrate her deception by abusing the sanctity of the church rather than using a register office for the marriage, and for this there could be no justification. He told the recorder there had been no banns and that the marriage was by license. 'You will realise how important it is that marriage registers should not be falsified.' The recorder commented that the maximum penalty for Mrs Arkell-Smith's crime was seven years imprisonment.

DETECTIVE INSPECTOR WALTER BURNBY TAKES THE STAND

The detective inspector's evidence confirmed what had gone before. Then he summarised Mrs Arkell-Smith's life, explaining the defendant was born on 27 August 1905 in Jersey of parents who were greatly respected. She arrived in England with her parents in 1912 and was despatched to a convent in Brussels for two years.

At the outbreak of war, she joined up as a VAD, although that could not be verified. She was employed in various ways during the war, and all of these occupations were undertaken as a woman. The detective inspector then confirmed her family details, finally adding that she and Pearce Crouch were estranged in 1923, having lived together for about four years. After this, she met Miss Haward, and it was at this time she began passing herself as a man, and continued to do so up until her arrest.

'I MUST HEAR SOMETHING OF THIS TRAVESTY OF MARRIAGE!'

Mr Clarke questioned Detective Inspector Burnby about the marriage (the actual question was not published in The Argus article) and the recorder said of Burnby's uncertain response, 'The witness must not be as vague as that. If there is anything that ought to be said, let me see it in writing. I do not want anything prurient to be stated in Court. Perhaps I can get it from Miss Haward.' But Mr Clarke insisted he did not wish to call Miss Haward.

Then Sir Henry Curtis Bennett for the defence said he had something to say: 'I object to its being given in writing in this way.' The recorder responded that he must learn something about this travesty of marriage and Sir Henry countered that it should be in a legal way. He began to examine the witness, establishing that Mrs Arkell-Smith had only had one charge made against her in her life of which she was acquitted; that, since

War work poster, 'We Can Do It'.

August 1914, she had been consistently employed; that she had supported her children, including paying for her son to attend a good school. She was a genuinely hardworking mother of two. As far as the bankruptcy charge was concerned, explained Sir Henry Curtis Bennett, 'the defendant has always said she never got it.'

ALFRIDA HAWARD'S EVIDENCE

After the doctor's statement regarding the Medical Examination, Alfrida Haward was called. The reporter described her as follows: 'A rather slight woman dressed in brown, with a brown fur and hat to match, she appeared nervous as she entered the witness box.' At this point, Mrs Arkell-Smith hung down her head, and avoided eye contact with Alfrida Haward, who was advised by the recorder not to be nervous.

Alfrida Haward confirmed she had lived with Mrs Arkell-Smith for about three years. Then Mr Clarke showed her a blue-pencilled passage from a typewritten document. 'Is that true?' he asked.

'No,' said Miss Haward, then adding that she didn't understand. 'It was true and it was not true,' she said.

Sir Henry asked her if she thought it was true when the incident happened, and she agreed that she did. She also agreed that she knew Mrs Arkell-Smith as Mrs Pearce

Crouch when she first met her, but she also understood Mr Pearce Crouch was not her husband.

'Did you understand the two children were hers?' asked Sir Henry.

'The boy, but not the girl.'

To Sir Henry's questions about Mrs Arkell-Smith's appearance when she first knew her, Miss Haward replied that her hair was cropped, but she couldn't remember whether it was long at first and subsequently cropped. Miss Haward confirmed that she believed Mrs Arkell-Smith to be a woman at that time, which was around the beginning of 1923. She also told Sir Henry that Mr Pearce Crouch treated Mrs Arkell-Smith very badly, including in her own presence. Arkell-Smith/Colonel Barker complained to Alfrida Haward that her husband consistently knocked her about and, in July 1922, she escaped from him and turned up at Miss Haward's flat.

Alfrida Haward remembered the defendant checked in to a Brighton Hotel as Mr Victor Barker in October 1923 and Miss Haward joined her there the next day where she remained with the defendant up to the date of the marriage, sleeping in the same room and bed. At this point, Miss Haward appeared faint and was offered a seat. She described how her parents, newly returned from their holiday, were told of her situation. Her father, believing Mrs Arkell-Smith to be a man, insisted that, under the circumstances, they must be married.

Repeating again the questions about what gender Miss Haward believed the defendant to be, and receiving the same answers, the recorder asked how the children were explained away. 'He told me the boy was by another woman and the girl was Pearce Crouch's,' explained Miss Haward. At the next question, she asserted that she did not discover Mrs Arkell-Smith's gender until she saw it in the papers.

'Were you sleeping in the same room?' asked the recorder.

'Yes,' said Miss Haward.

'You never knew from first to last?'

'Never, after she told me she was a man,' replied Miss Haward and then added, 'She left me some years ago for another woman.' When asked how Colonel Barker kept up the deception, Miss Haward said, 'I don't know.' She said everything appeared perfectly normal and he appeared to behave as a husband would to a wife.

'After the form of marriage,' asked Sir Henry, 'did you always occupy the same bed?'

'Not always.'

That was the end of Miss Haward's questioning and she was allowed to walk slowly to the back of the court to her seat.

THE GREATEST PUNISHMENT – PLEA FOR THE DEFENCE

Sir Henry Curtis Bennett began his speech for the defence, pointing out that in a case of this kind, the court would be surrounded with prejudice, but it should be dealt with on its merits alone and he asked the court to put 'those matters' out of their minds.

> One of the greatest punishments the defendant has already been made to suffer is that members of the public come to gaze at her wherever she moves. At the police court, she had to be got away in secret ways. Wherever she goes when she is out of doors she is followed

about. Today, even some people are taking an interest for sorry reasons in her having to stand in the dock. That is a very serious punishment for any man or woman.

ALSO IN MITIGATION – A HARD-WORKING HISTORY

Sir Henry pointed out that the defendant was a very hard-working woman up to 1923, when she changed her sex to the outside world from a woman to a man. At nineteen, she joined the Red Cross and was employed in Haslemere, Surrey. At the beginning of 1915, she went to France and drove ambulances right up to just behind the lines for twelve months. Early in 1916, she returned to this country as her nerve had broken. From the summer of 1916 to March 1917, she was head lad – although known as a woman – to the Shropshire Hunt. In autumn 1917, she went to the Military Remount Depot at Bristol and there she dressed as a male, in fact, as a land-girl.

She was engaged in looking after and breaking in horses, and in 1918, she met Mr Arkell-Smith whom she married in April, aged twenty-three, but the marriage was doomed from the beginning due to her husband's heavy drinking and his ill-treatment of her. It was so bad she left him after only six weeks. During the marriage, she only ever received £25 from her husband and had received no allowance from him since his return to Australia. Subsequently, serving as a driver for a mess officer, her duties included ordering for the mess herself. After the war, at Westminster, she met Pearce Clarke and after six months, they began to live together. Pearce Clarke was demobilised in April 1919 and went to work in Paris and their son was born in February 1920.

THE GREATEST ORDEAL OF HER LIFE

Sir Henry Curtis Bennett, for the defence, said the last thing the defendant had wanted was to get married at all. Miss Haward was then twenty-seven and Sir Henry suggested that it was idle to suggest that Miss Haward did not know perfectly well she was living with a woman. But her father naturally believed the defendant to be a man, and it was as a result of his insistence on the marriage that the defendant was placed in that position for so many years.

'Today she was going through the greatest ordeal of her life,' he added.

The recorder, Sir Ernest Wild, KC, said it was a case of unprecedented and peculiar character. He needed time before passing sentence so the verdict was postponed until the following day.

SENTENCE IS PASSED

On 25 April, *The Argus* reported that 'Colonel Barker' had been sentenced to nine months imprisonment in the Second Division. Again, the public gallery was full, although the paper reported 'fewer fashionably dressed ladies.' Mrs Arkell-Smith, however, had now emphasised her masculine appearance. She was allowed to sit while sentence was passed. 'You have had the advantage of being defended by one of the most able and

eminent advocates at the Bar, Sir Henry Curtis Bennett,' began the recorder, Sir Ernest Wild. 'He has made what I may describe as a masterly defence on your behalf.'

Then the recorder voiced his rejection of the argument, which, he said, might be relevant in a case of bigamy, but was irrelevant in a charge of perjury. He said Mrs Arkell-Smith's situation was described as though she was on the 'horns of a dilemma' because, having lived together with Miss Haward, she was forced to agree to the marriage due to Mr Haward's insistence. 'In my judgement, you were on no such horns. You had merely to show that you were a woman. I cannot see how it could have put you in any difficulty. It may have disturbed your pride, but it was no such dilemma as it would have been, had you been a man.'

Sir Ernest Wild continued by saying he was impressed by Miss Haward and her assertion she had believed the defendant was a man, and also believed the explanations about the children. Even so, disregarding the truth or falsity of Miss Haward's evidence, he said that in considering the case, he felt Miss Haward must have know the defendant was a woman even before the illegal marriage. He would, however, mitigate the sentence because of the morbid interest the case had aroused, which was part of the punishment for the defendant's 'perverted conduct'.

SCATHING REMARKS

Describing the defendant as an unprincipled, mendacious and unscrupulous adventuress, he added, 'You have, in the case before me, profaned the House of God, outraged the decency of nature and broken the laws of man. You have falsified the marriage register and set an evil example which, were you to go unpunished, others might follow.'

Sir Ernest said the maximum sentence he could impose was seven years penal servitude but, using all leniency he could, he passed sentence of nine months in prison in the Second Division. *The Argus* report said the accused was unmoved by the sentence, rose to her feet, bowed to the recorder and was escorted by a warder to the cells below. 'At one point only did Mrs Arkell-Smith display any emotion. This was during the scathing remarks of the recorder. The defendant had shrunk into her chair and lowered her eyes to the ground. She was in tears, but she pulled herself together, gradually regaining her former calm.'

The couple had been married at St Peter's, Brighton's parish church and honeymooned at The Grand Hotel.

Mrs Arkell-Smith's biography can be found in Rose Collis' book *Colonel Barker's Monstrous Regiment – A Tale of Female Husbandry* (2002).

14

ALL THE NICE BOYS
LOVE A SAILOR

During the Second World War, Brighton and Hove were often targeted by enemy planes, which offloaded bombs before they returned across the Channel. Around twenty bombs fell on Kemp Town. This was a time in Brighton's history when it was not visitor-friendly; casual trippers to the town were discouraged and barbed wire was spread over beaches.

A book review by Gordon Thomas in *The Argus*, dated 29 March 1962, claimed that Hitler had planned to invade Sussex on 21 September 1940, but he postponed the operation for three days. After this, he dithered again as the Luftwaffe was unable to gain superiority in the skies over Sussex and the Channel. There was decision and postponement throughout that September; 'on and off, on and off, like the water supply in Brighton that summer,' said the paper. Finally it was off. (The book reviewed was *Operation Sea Lion* by Richard Wheatle.) It's claimed that Hitler had intended to turn the Royal Pavilion into his headquarters immediately after he had invaded.

During the Second World War, the pupils at Roedean School in Rottingdean were evacuated to Keswick in the Lake District. The Admiralty occupied the building and most departments of HMS *Vernon*, responsible for mine disposal, moved to Rottingdean from their quarters at Dido Building, Portsmouth, where they had suffered heavy air raids. The occupation of many sailors in the town provided great excitement for the male gay community of Brighton. There were Canadians and Australians and many meetings took place around the clock tower at the top of North Street. Gay men hung around outside the gates of Roedean School, knowing there were plenty of places to go because of the blackout.

In his article 'The Good Old Gays' in *3SIXTY* magazine, dated March 2005, Jamie Hakim says the Royal Navy placed the Star of Brunswick in Little Western Street East out of bounds during the war. This was due to its popularity with the sailors. Ex-servicemen came to Brighton on holiday and some stayed to make their homes here. Some guest-houses, for example, St Albans Hotel in Regency Square, the Cecil Court on Kings Road and Le Chateau Gaye in Castle Street, would 'turn a blind eye' to the gay goings-on, and this information passed swiftly along the gay grapevine. (Sometimes, the owners themselves were gay.) Gay men discovered the names of gay venues through being warned against them by the locals.

'The Good Old Gays' describes how a London man came to Brighton in 1946 to meet his first gay friends on the Men's Beach at Hove. 'There was so much beauty down there,' said the Londoner. 'It was fantastic. Of course, they never went in the sea, they just went to be seen. It was flagrant fun.'

Roedean School. (© Janet Cameron)

The Sussex Arts Ball started at the Aquarium (now Sea Life) in 1947 and attracted local cross-dressers including a drag artist called Betty Lou, who dressed like a peacock; her sequinned costume stood twelve feet high. 'It was absolutely beautiful,' said a young man called Michael. 'The bodywork was all done in glistening sequins and pearls.' But some people were less comfortable with the gay scene, as in the following account of a day trip to Brighton in 1949: 'Arthur, Michael, Peter and I went into a small bar which was full of about thirty-five males – the vast majority of whom appeared to be homosexuals. Frank refused to go into the bar, saying that he just didn't want to. Frank is the clandestine type of homosexual; he heartily disapproves of all varieties of 'camp'; he would never be identified as a homosexual.'

Jamie Hakim acknowledges Brighton Ourstory Project's documents and website for preserving the city's gay and lesbian heritage and for informing his article.

15

POST-WAR AND 'THE CLOSET'

Even in the suppressed forties and fifties, it seems that, in certain respects, Brighton was already displaying a little more tolerance towards sexual freedom than some towns, as indicated by an article in *The Brighton and Hove Gazette* on 29 January 1940. Worthing public library had recently decided to ban a book entitled *The Captain's House* by Mary Edginton after a local councillor had been deeply shocked by its racy content. However, there were still four or five copies available in Brighton Library.

The paper pointed out that there were, originally, sixteen copies, and that the rest had been withdrawn. But Mr C. Musgrave, director of the library and Pavilion estate told *The Gazette*: 'They have been withdrawn because they are worn out. I don't think it's for any moral reason.'

There were no complaints in Brighton.

OVER THE FOOTLIGHTS!

On 6 February 1943, *The Brighton and Hove Gazette* reported that at the Brighton Dome Mission, the Revd O. H. Simpson spoke disparagingly about actors. 'I cannot understand how any decent person can sit in a place of amusement and listen to a stream of filth coming over the footlights without making a protest.' The reverend called on people to boycott the theatre, because the actors relied on box office returns. Once the returns went down, 'the filth would stop'.

. . . AND IN THE CLUBS

Brighton's bogus drink clubs had become a scandalous source of drunkenness and contacts for immorality, said Mr H. L. V. Pearns, speaking at the AGM of the Brighton & County Licensed Victuallers Protection Society and Friendly Association. The meeting was held at the Richmond Hotel. Mr Pearns said that licensed houses reached a very high standard – it wasn't the pubs but the clubs who were to blame – and certain other places of ill fame and a cause of trouble to the police. (*The Brighton and Hove Gazette*, 20 February 1943.)

THE WRONG KIND OF PERSON!

Ald. J. E. Hay described Brighton as 'a town of funfairs and whelk stalls,' according to *The Brighton and Hove Gazette*, dated 4 March 1950. The comment was made during a

Terence Rattigan lived at 79 Marine Parade. (© Gareth Cameron)

debate on the plan for the use of the Aquarium terraces (now The Sea Life Centre) from the forthcoming Easter to October period. Further, said the alderman, the towns were attracting the wrong kind of person. 'Good class people have gone. People who come to Brighton even bring their own beer. They come to Brighton to spend the day and that's all they do spend – the day.'

FORCED TO LIVE A LIE

Playwright and pacifist Terence Rattigan (1911-1977) was a closet homosexual at a time when such an admission would prove disastrous for both personal life and career. Rattigan went to great pains to conceal his sexuality from his parents and from the public, refusing to live with anyone. He co-wrote the screenplay for the 1947 film adaptation of *Brighton Rock* along with author Grahame Greene. The climax of the film deviates from the Peacehaven setting of the book, taking place, instead, at Brighton's West Pier.

The Evening Argus of 5 February 1952 reviewed his play *The Deep Blue Sea* performed the previous night at the Theatre Royal in Brighton. Under the heading 'The New Rattigan, His Best Yet' the reviewer says, 'As a serious playwright, Mr Rattigan grows in stature and perception with each new play. His characters are created with a compassionate insight and delicacy of observation which gives them greater depth . . . he dissects their personalities and even their souls and lays them lovingly before his audience.'

Terence Rattigan's plays continued to be shown and will be admired for decades to come.

16

BOOK ADMITS 'IT'S NOT A "MEDICAL CONDITION" '

KINSEY AND SEXUAL BEHAVIOUR

Alfred Kinsey's book *Sexual Behaviour in the Human Male*, published in 1948, challenged Freudian beliefs that homosexuality was due to psychiatric disturbance. For Kinsey, all individuals fitted on a continuum of sexual preferences – and might, during their lifetime, shift from one part of the scale to another. Men in category 1 had no interest in homosexual outlets, while category 6 men preferred nothing else. Men often moved between the categories during their lives. According to author Andrew Wikholm, the book became a bestseller while provoking controversy and dissent.

A few years later, in 1953, Kinsey's *Sexual Behaviour in the Human Female* appeared, and caused an outrage when he said that lesbians were better at giving partners a climax than males. He also claimed that women who had premarital sex experienced more orgasms after marriage. Andrew Wikholm adds that some congressmen suspected Alfred Kinsey of being a 'fifth columnist' working to erode America's morals and weaken her against the communists. Alfred Kinsey's research grant was withdrawn after this charge.

I HAVE A RIGHT TO MY LIFE!

In spite of the Kinsey Report, homosexuality was still regarded as a medical condition or a disease that could, perhaps, be medically treated. A young man brought up on two indecency charges, reported in *The Argus* on 3 January 1952, was offered choices between becoming a voluntary patient at a mental hospital or being jailed. Mr A. had already been in custody for three weeks pending medical reports. It was claimed he needed treatment for schizophrenia.

At a previous hearing, Mr A. had pleaded not guilty to the charges, but later 'admitted he was the man responsible for the bad actions but he had not done them intentionally.' He had a sister, with whom he had been living in Brighton, but she couldn't take him back, and his brother had insufficient room in his accommodation to help him.

If he agreed to go into hospital as a voluntary patient, he could be placed on probation for a year. Otherwise, it was prison. Mr A. said he had a right to a decent life. He didn't think people should make others do things against their will. 'I've got my life to live,' he told the magistrates. The chairman told him he would have to go to prison for two months.

'He never hid his sexuality,' said the report. 'He was honest to himself in every aspect.'

THE WOLFENDEN REPORT (1954) AND HUNTLEY & PALMERS

It was in this hostile, anti-gay climate that the Wolfenden Report committee met for the first time on 15 September 1954 and another euphemism was invented. To spare the sensibilities of the ladies present, John Wolfenden suggested using the terms Huntley & Palmer (Huntley = homosexuals, Palmer = prostitutes.) The meetings continued for sixty-two days and included interviews with police, probation officers, psychiatrists, religious leaders and gay men.

The committee's recommendation was: 'Homosexual behaviour between consenting adults in private should no longer be a criminal offence.' Except for one dissenter, it was found by the committee that homosexuality was not a disease because, in many cases, it is the 'only symptom' and is compatible with mental health in all other respects.

The report stated, 'The law's function is to preserve public order and decency, to protect the citizen from what is offensive and injurious, and to provide sufficient safeguard against exploitation and corruption of others . . . It is not, in our view, the function of the law to intervene in the private life of citizens, or to seek to enforce any particular pattern of behaviour.' Age of consent was to be twenty-one, which was then the UK's age of majority.

Wolfenden's son, Jeremy, was gay but fortunate to have an enlightened father.

CONTRADICTIONS

On 26 October 1957, *The Brighton and Hove Gazette* published an article headed 'Sex Proposal Hazardous'. In a diocesan leaflet, Dr G. K. A. Bell, the Bishop of Chichester, had voiced his disapproval of the recommendations of the Wolfenden Report in attempting to legalise homosexual relation between consenting adults. The bishop said, 'To desire to do everything to help persons suffering from this temptation is one thing. But to reduce the gravity of the offence in the public mind by lifting it out of the category of things forbidden by law into the category of things not so forbidden is quite another.'

In the same issue of *The Brighton and Hove Gazette*, a further article appeared entitled 'Role of Religion'. Here it was noted that Dr Bell visualised himself as a bridge-builder – he strove to build bridges between the Church and the artist, the Church and the Poet, the Church and the theatre, and, in some small way, the Church and the Press. (Capitals for nouns as read.) The bishop went on to plead for racial, national and class tolerance and against totalitarianism and war. He wanted to speak for the prisoner, the alien, the Jew, the refugee and all victims of persecution. He did not, on this occasion, specifically mention one of the most marginalised groups of them all.

A further example of mixed messages appeared in *The Brighton and Hove Herald*, dated 2 November 1957. The Head of Malvern College, Mr Lindsey, told the girls of Roedean School they would have to be supermen to compete with boys, because they were to compete in a world where jobs went to men. In the same speech, he advised the girls not to go entirely for examination success and not to try to be boys instead of girls. The fifties were a confusing time for all young women seeking a personal identity, regardless of their sexuality.

17

SEX, LOVE AND MARRIAGE

Brighton comedienne and writer Ann Perrin, who lives in Saltdean with her partner Alan, says that some gay men in the first half of the nineteenth century made marriages of convenience. Ann's working life has been spent in the theatre and she has had the opportunity to meet many people. She explains that sometimes marriages were by mutual arrangement, but sometimes the person had not yet acknowledged or had even suppressed their sexuality, leading to tragic consequences. Some gay men would choose to leave their wives and pursue their own lives without the wives being aware of the reason. Others, who decided they could no longer live a lie, were more open and humane in their actions. 'I became homosexual after my marriage,' says one seventy-three-year-old gay man. 'But I told my wife. Although it was a terrible shock to her, she understood why I had to leave her. We are still good friends.'

OF MUTUAL BENEFIT

At a gay-friendly venue called Piggot's Bar, frequented by both lesbians and gay men and located at the St James Tavern in Madeira Place, two lesbians, Miss J. and Miss K. fell in love. Ron Forrest describes how Miss K. met a Lancaster Bomber pilot. The pilot was a former wing commander who was still in the RAF, and because he was gay, he was desperate to marry to protect his rank. He and Miss K. agreed to get married so that he could safely pursue his career and Miss K. could receive the married woman's allowance, making a mutually beneficial alliance. The two, although in a non-sexual 'marriage of convenience' were great friends and companions. Ron Forrest recalls how Miss K. made him an excellent Victoria sponge cake for his twenty-first birthday in 1951.

Ron also mentions that he met a former partner at Piggott's Bar. Other popular rendezvous for gay people Ron remembers were The Forty-Two Club, 42 King's Road with its upstairs gay bar. It's claimed that Tony Stuart ran the Forty-Two Club on the seafront for over twenty years, and while some say it was launched during the 1950s, other reports state the 1960s. However, it continued at least until the '80s so it was probably one of Brighton's longest-running gay venues.

DARE TO BE DIFFERENT!

The sixties witnessed the Battle of Brighton between the mods and rockers in May 1964 (Hastings had a similar event at Easter, which they called the Second Battle of Hastings)

The Fortune of War. (© Janet Cameron)

and the arrest of William James White in the summer of 1966 for dancing on Brighton's Lower Esplanade with large feathers in his hair for the amusement of children. He collected coins for his efforts in a green felt hat, incriminating himself as a beggar and received one month's imprisonment. In such a climate, with its deeply entrenched youth gang culture, it was difficult for anyone with a smattering of individuality. In Brighton and Hove, the police still raided gay venues and recorded names and addresses of patrons in their notebooks.

Besides Piggott's Bar, gay meeting-places in the fifties and sixties were The Spotted Dog, which is now the Hop Poles, The Greyhound with its gay upper bar (now the Fishbowl) and The Golden Fleece in Market Street. One day, says Ron, the landlord of the Golden Fleece moved out 'and then everything changed'. Another popular venue was the Albemarle near Brighton's Palace Pier, a good choice for a saucy weekend as you could stay the night. Two bars on the seafront, the Fortune of War and The Belvedere were favourite haunts of lesbians

Historian, Geraldine Curran remembers the Star of Brunswick in Little Western Street in the late fifties, early sixties. 'There were a lot of theatrical people living in the Brunswick/Adelaide area around that time. It was considered a bit racy,' she says. 'At one time our lovely local was frequented by Noel Coward and Bombadier Billy Wells. Billy was one of many "beefcakes" who used to beat the Rank gong. He used to sit on the same bar stool at the corner of the bar.'

<div style="text-align: center">

18

ENTERTAINMENT IN THE SIXTIES

</div>

DUSTY SPRINGFIELD, A BRIGHTON ICON

This was the decade of stunning gay icon Dusty Springfield (1939-1999), who lived at Wilbury Road in Hove where she formed her group, The Springfields. She appeared in concert at the Brighton Hippodrome with Eden Kane in August 1964. The husky-voiced soul singer, famous for her big blonde hairdo and sooty lashes, died in Henley-on-Thames of breast cancer. The Brighton Hippodrome, at 52-58 Middle Street, closed in 1964, and later, in 1979, opened as a bingo hall.

REMEMBERING DUSTY SPRINGFIELD

On 7 February 2006, BBC News reported that a Brighton and Hove councillor, Mr Bill Randall, wanted to introduce a 'pink plaque' scheme to the city, commemorating contributions made by local LGBT. Eventually, the plaques might be linked and used to create a gay and lesbian heritage trail. Mr Randall specifically mentioned that Dusty Springfield was one person who should be remembered in this way.

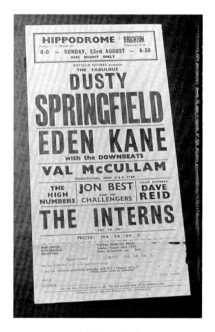

Dusty Springfield handbill.

SISTER GEORGE

Gay men gradually became bolder so that two men holding hands in public became a common sight in Brighton and Hove. But, as before, lesbianism was not 'in the closet' because it was still largely unrecognised and so lesbians had their own specific problems. Their profile was low, which meant they were protected to some degree from the general abuses suffered by gay men, and often lived together quietly in pairs without being challenged, as single women might do who aren't sexually involved and share a home for reasons of friendship and/or financial benefit. Lack of recognition meant many

people did not understand lesbian women might be victims of domestic violence. Then a film portraying this phenomenon appeared on cinema screens across the country, although not necessarily in the uncut version. Brighton proved more tolerant than some other towns.

SISTER GEORGE GETS THE 'ALL CLEAR'

Hove cinema audiences were to be allowed to see the 'uncut' version of *The Killing of Sister George*, including even the controversial bedroom scene between the two actors – or actresses as they were called then. The story involves a love triangle: Beryl Reid portrays a cigar-smoking gin-drinker, Susannah York is her childlike flatmate and Patricia Medina plays a prostitute. *The Argus* of 21 October 1969 reported that several members of the Legal and Parliamentary Committee attended a special showing of the film in Brighton the previous month. They reported back to the full committee, whose agreement that the film could be shown unabridged in Hove was unanimous, although it would be awarded an X-certificate. Formerly, the British Board of Film Censors had cut the bedroom scene between the two lesbian characters. Councillor John Edwards sensibly said, 'There was only one scene that was questionable and that was an essential part of the story and not put in for sensationalism.'

The Brighton and Hove Herald's Mary Richards gave a favourable but cautious review on 21 November 1969. She felt it took a strong stomach to take it. 'The lesbian side of the story, even the controversial love scene, is handled with what I suppose could be called "good taste" ', she said guardedly.

GAY AND PROUD OF IT

David Watkins (1925-2008), a leading British cinematographer, who was born in Margate, died aged eighty-two at his Sussex Mews home in Brighton on 19 February 2008, as reported by Richard Gurner in *The Argus*, dated 21 February 2008. He was celebrated for his work on *The Beatles – Help!*, *Jesus of Nazareth* and *Chariots of Fire* and won an Oscar for *Out of Africa* (1985). His friends described him as warm, honest and friendly and a 'pioneer of bounce lighting' (i.e. reflecting a light source off a white surface). He was always ready for a challenge, and in 2004, The British Society of Cinematographers gave him a lifetime achievement award.

David Watkins was the youngest son of a solicitor and his homemaker wife. He joined the army in the Second World War, then worked as a camera assistant, gradually working his way up until he was able to freelance in the 1960s. David Watkins was gay, upfront and proud of it.

19

NOT SO SWINGING

The opportunity for meeting kindred spirits was still problematic for gay men, especially those in positions of authority, some of whom preferred the anonymity of making contact in public conveniences. Aware of this, the police took to following a priest who vehemently claimed he was innocent of soliciting. His case shows how much a professional person stood to lose if convicted.

CASE DISMISSED – FOR LACK OF EVIDENCE

The clergyman's ordeal was reported in *The Brighton and Hove Gazette*, dated 15 October 1965. Father William Fitzgerald was a fifty-year-old Roman Catholic priest in Woodingdean and he protested vehemently that he was not importuning for immoral purposes. He was fortunate to have a number of supporters who gave him excellent character references. He'd moved to Woodingdean to minister to his new parish twenty-three months previously. There was a heavy bank overdraft that had to be repaid and funds to be found for a church building and, if possible, a school. At the time, he hadn't been able to buy land and held his services in a school hall. It was all a heavy responsibility, in addition to which, his mother was sick and depended on him. 'I do worry about things, particularly as far as money is concerned,' said the grey-haired priest.

 Father Fitzgerald insisted that on the night of his arrest, he'd been trying to escape from everyone, and not trying to attract anyone for immoral purposes. 'I did not want to see anybody,' he said. 'I did not want to talk to anyone. I could not, on that day, even speak to my mother.' But two police officers told the court they followed the priest from one public convenience to a second one. This took place within one hour. There is no mention in the report that the police officers witnessed any sexual activity and when Father Fitzgerald was arrested, he was horrified. 'No,' he told them, 'you are mistaken.'

 Dr John O'Hara of Rottingdean was called by the defence and said he had feared two days before the priest's arrest he was verging on a nervous breakdown. 'If he had not been a Roman Catholic priest, I fear he would have made an attempt on his life. I wrote to him afterwards and told him if he wanted to get well, he should ask his bishop to transfer him to a quieter parish.' Father Langton, rector of seminars at a Roman Catholic college described the priest as a self-contained man who would not seek help from others. 'He was a man of deep moral purpose.'

 The magistrate retired for just ten minutes and then dismissed the case.

COURT HEARS A NEW 'LABEL' FOR COMMON BRUTALITY

A new label began to appear in the newspapers in the sixties – a new label for an old crime. Hooligans went out looking for people who appeared to be gay, attacked and robbed them, confident they would get away with it, as their victims would be unlikely to complain in view of the overt homophobia of the period. But one man got it badly wrong.

A Brighton man was put on probation for three years according to a report in *The Brighton and Hove Gazette*, dated 23 September 1966. Inspector William Tapsell, prosecuting, told the court, 'This is a crime of what is known as queer rolling. We get quite a bit of it, especially on the seafront.' In this case, it was a heterosexual male who was assaulted – and he was able to complain, a right he may not have exercised had he been gay. The prisoner was remanded in custody for three weeks for mental, medical and probation reports.

Later the same year, on 12 October, a report appeared in *The Brighton Evening Argus* about two Brighton teenagers who appeared at 'Essex' Assizes (a possible misprint) for robbing men in the town of Brighton whom they suspected of homosexuality. The two teenagers pleaded guilty to armed robbery and assault. One man also pleaded to a further charge of armed robbery and was sent to a detention centre for six months.

One prisoner had acted alone and this incident concerned a waiter with whom he conversed on the seafront and who took him home. The prisoner coshed him and took money and property from him. The other incidents took place on different occasions and involved both defendants. In two cases, the victims were robbed, but in the third case, the victim managed to escape and his cries of distress were heard by the police officer.

It emerged the men committed the 'queer rolling' for easy money, one because he was out of work and his girlfriend was expecting a baby, while the other wanted to go on holiday. Both youths had been in court previously, one having nine other offences on file, and the other three.

THE SEXUAL OFFENCES ACT OF 1967

The Sexual Offences Act of 1967 decriminalised male homosexuality between consenting adults in private. The Act was based to some extent around The Wolfenden Report, but received criticism because of the unequal age of consent (twenty-one) in comparison with heterosexual legislation and also took a rigid stance on privacy, so that male homosexuals would still be vulnerable to prosecution. The Act applied to England and Wales (but not the armed forces or the merchant navy). Despite this, people in prominent positions frequently lost their jobs if they were suspected of homosexuality, even if the so-called 'offence' took place between consenting adults.

In 1969, in New York, the March on Stonewall took place to protest against discrimination and violence against homosexuals.

20

MIXED MESSAGES IN EDUCATION AND THE MEDIA

The sixties may have been the decade of the beginnings of sexual enlightenment, but genuine change was gradual and miscarriages of justice continued. For lesbians, this striving for recognition had to address issues not only of their sexuality, but those of gender too. The equality of women was, if not in its infancy, still in primary school.

On 23 July 1965, *The Brighton and Hove Gazette* published a report about a one-day careers course on engineering. Mr Colin Mares of the Mechanical Engineering Department said, 'There were more girls at the conference than we expected.' Moreover, the facilitator was bombarded with questions from the girls. The problem was, said Mr Mares, it was expensive to train engineers – and the girls might leave to get married after a couple of years. It was true they might return to restart their careers after bringing up their families, but advances in engineering were so rapid, there would be the expense of training them all over again. Even for young girls intent on marriage, this was hard (and, of course, some of them were – and it was). But it must have been even more difficult for those women desiring women, for whom traditional marriage was never an option. Buying a house to live in together must have been an impossible dream for most lesbians.

UNDERLYING PREJUDICE

Apparently well-meaning people sometimes expressed opinions that betrayed their innermost, half-suppressed prejudices, as some of the following cases demonstrate.

Katharine Whitehorn, writing in *The Observer*, dated 23 January 1966, comments on the common idea that sex must be the dominant drive in every person's life.

> You sit up half the night listening to the wails of some jilted bachelor, only to hear a casual bystander say, next day, that, so old and so unmarried, he must be queer. Not a psychological work that doesn't owlishly repeat that Lesbian couples are not frowned on in our society, since pairs of single women live openly together – rather missing the point that only those with absolutely one-track minds ever think they are Lesbians at all. I often wonder what the real Lesbians think about this unwarranted swelling of their ranks.

The implication seems to be that the only reason lesbians were not frowned upon was because it was 'normal' for pairs of women to share accommodation and that you were sexually deviant if you happened to spot lesbian traits.

Lesbian writer, Emma Donnaghue, in an interview with Heather Aimee O'Neill on 12 January 2008, comments on this particular construct. It's inspiring how she

manages to make a positive outcome from an identical sexual situation. 'What I love about writing about sexuality before the 1990s is that the labels didn't really fit on neatly...If you were a woman living with a woman, your neighbours didn't all say, 'Oh yes, those lesbians there.' You might get some neighbours who thought you were charming, virtuous women and others who thought you were peculiar social losers, and others who thought perhaps you were sexual perverts, and there was a real range of interpretation and that meant people were, in a way, freer to have really odd lives.' (www.afterellen.com)

WHY GAYS SHOULD NOT BE SENT TO PRISON . . .

A case is revealed in *The Brighton and Hove Gazette* report of the 19 November 1965 entitled 'That word! Woman M.P. slams critics'. This concerned a certain four-letter word uttered on the BBC, subsequently eliciting fury from a shocked general public.

The M.P. spoke at the Annual Women's Conference of the Brighton and District Co-operative Party the previous Wednesday. She expressed her amazement at the level of energy expended on the subject, while people showed 'no signs of activity about the many cruel problems that defaced our society and disfigured the lives of many people in the world today.'

The M.P. went on to list ways people could help, including writing to M.P.s to urge them to deal with complaints about the hypocrisies which our laws continue to endorse or taking a 'half-caste' child from a council home into the family for the weekend. She also slammed into 'cruel legislation which sent homosexuals to prison, which could only enhance their *disabilities*.' (author's italics)

A WOMAN CALLED 'ANNE'

A happily married man with two children had a 'dreadful problem', and wrote to *The Argus* describing his compulsion to dress up as a woman. He loved his wife deeply and had no intention of looking for anyone else. He told the Agony Aunt of *The Argus*, dated 14 October 1969, that this urge had been with him since he was a small boy. He thought it was because his mother had wanted a daughter and sometimes, when he was a child, she dressed him as a female for parties or for her personal amusement. The writer felt peaceful when he was dressed in women's clothes, while, as a man, he felt untidy and unhappy. But he wasn't homosexual and couldn't think why he still did this. His wife knew about his urges. Although she didn't entirely understand, thinking he was 'mixed up', she was tolerant. As a woman, he liked to be known as 'Anne'.

His main anxiety was that his compulsion might do psychological damage to his children as they grew up, if they discovered their father liked to 'pretend to be a lady'. He wondered if he should tell them or whether to keep it secret. Finally, he asked the Agony Aunt if there were others like him – or was he just a dreadful mistake of nature?

The advice given was fairly reassuring; bearing in mind this was the 1960s. Many men wore clothes that were anything but masculine, including beads, bracelets and rings, and styled their hair in a more feminine style and it was sometimes difficult

to recognise a person's sex. But, on the other hand, there may be deeper underlying problems, particularly as he had adopted a special female name for when he was dressed as a woman.

'Your own explanation of the situation may be correct, at any rate, in part, but I'm no psychiatrist. It is obviously specialised advice you need.' He was advised to go to his doctor to find the advice he needed and not to shelve the matter – for the sake of his family and for himself, 'but you can rest assured you are not the only man with this problem.'

21

PROSECUTED UNDER THE OBSCENE PUBLICATIONS ACTS
A TEST CASE

When any poet writes or an artist paints, he is under oath to something inside himself to tell the truth and the whole truth. Not to tell just those parts of the truth which are palatable and pleasing, but all that is true – the good and the bad parts. Until he does that he is incomplete as an artist and as a poet.

Mr William Huxford Butler, at his trial.

The 1968 trial of a thirty-three-year-old Brighton bookseller at Brighton Magistrates Court for trading in obscene books, including books of a homosexual nature, caused uproar among thinking people and academics.

Mr William Butler operated his business from The Unicorn Bookshop in Gloucester Road, Brighton. According to a report in *The Brighton and Hove Gazette*, dated 23 August 1968, the defendant was a poet and academic and was being summonsed by the Director of Public Prosecutions under the Obscene Publications Acts of 1959 and 1964. An American who was permanently resident in this country, William Butler was now living at Over Street in Brighton.

One of the books the prosecution took issue with was *Poems* by John Giorno. John Giorno, born in 1936, was an activist in the gay community and he subsequently established an AIDS Treatment Programme in the 1980s, working tirelessly for the benefit of others. William Butler told the Brighton magistrates that the Giorno poems were 'nasty, agonising and honest – and had literary significance.'

The trial was set for the following week and reported in *The Brighton and Hove Gazette* on 30 August 1968. There were three magistrates, two men and one woman, and ten summonses, although one was dropped because the named book was never sold in Mr Butler's shop. William Butler, a poet of standing, had support from distinguished academics – indeed, it was stressed that most of the books were purchased by lecturers, students and ex-students, and included on the Unicorn's mailing list were such institutions as Wellington College and Christ's Hospital (not a hospital, but a public school).

One of the books mentioned was *Hunkie's Journal*, said to be part of an autobiography of a person with homosexual tendencies but claimed by the defence to have literary merit. Another was the *Evergeen Review* series. Mr Arnold Melvyn Goldman, lecturer in English Literature and American Studies at the University of Sussex, said he regarded the *Evergreen Review* as having literary merit. Another supporter, Mr Eric Mottram, claimed he had put forward the *Evergreen Review* as 'recommended reading' to King's College Library, and he had encouraged the college to buy a complete set.

A witness, Anthony Godwin, once editor for Penguin Books, said that anyone sincerely interested in writing would seek out avant-garde books and contemporary poetry, while a Sussex fiction writer, John Pudney, spoke of the dangers of censorship. Mr Pudney said that, although he didn't advocate the abolition of the Obscene Publications Acts, he realised they were obscure and difficult to apply. He suggested certain kinds of people might be corrupted by reading the Marquis de Sade, *Alice in Wonderland*, the Bible and Shakespeare.

One of the magazines was seized because it contained a passage from the Marquis de Sade's novel *Justine*. But *Justine* was available in bookshops and libraries all over the country, including Brighton Library. Also, specifically mentioned once again, were the Giorno poems which aroused great hostility and evoked an outburst from Mr Ripper, 'This is a filthy book – one of the worst it has ever been my experience to read,' as did another book with the title: *Why I Want to … Ronald Reagan*. (Title exactly as shown in the report with excluded expletive.)

It was pointed out that the attitudes of the younger generation were changing, and they felt their elders were stuffy, illiberal and narrow-minded. But this didn't wash with the magistrates. 'Do you think this is suitable literature for schoolchildren?' Mr Worseley demanded of the defendant. William Butler replied: 'I would not. They would not understand it!'

Due to the confiscation of his stock, Mr Butler admitted he was in financial difficulty, although he was confident he would recover. Although 3,000 volumes had been seized, Mr Butler insisted his main concern was his services to the study of literature. Mr Joseph, the defence counsel said that the Acts under which the prosecution were brought were 'virtually unworkable laws'. He said, 'It is a misbegotten law and I am not alone in this opinion.' He pointed out that William Butler had not become a seller of 'dirty books' in order to make a profit. On the contrary, he was dedicated to literature.

The magistrates found against William Butler. Legal aid was refused and he was fined £230 and 180 guineas for costs. On its front-page summary, *The Gazette* reported that there was uproar in the public gallery at William Butler's conviction. The chairman, Mr H. J. Ripper said, 'May I say how appalled my colleagues and I have been at the filth that has been produced in this court, and also that responsible people have come here to defend something which is completely indefensible. We hope the university authorities will take note.'

A longhaired young man in a bright blue shirt leapt up and shouted from the gallery, 'I reject the authority of this court. This is a case of police victimisation.' He was immediately removed, still shouting.

'I have nothing more to say,' said Mr Ripper.

'You have said enough,' shouted another man.

The case was, said the paper, one of the most important obscenity prosecutions of recent years and a 'test case'.

NB: Other publications specifically named were *Cuddons Cosmopolitan Review* No. 11 and *The East Village Other*.

You can read three of John Giorno's poems on www.barcelonareview.com

22

THE CASE FOR A NATURIST BEACH AT TELSCOMBE CLIFFS

There was a long-running debate in the papers concerning Telscombe Beach, which had been 'taken over' by naturists. *The Brighton and Hove Gazette* of 25 September 1965 quoted the council chairman, Mr R. W. Pitcairn, who said, 'Discretion is the operative word. Large numbers of people using the beach are exercising no discretion whatsoever.' Townspeople were anxious the beach should not become a 'Mecca for Nudists'.

PASSPORTS FOR TELSCOMBE BEACH!

According to *The Brighton and Hove Gazette* of 8 October 1965, locals had decided these were 'the wrong kind of naturists' and there was a motion that passports should be issued for 'genuine naturists' in order to 'get rid of the 'abnormal' people who have flocked to the beach in recent months. Part of the trouble was that the cliff top was used as a gathering place for youths to shout obscenities at the naturists. Also car parking had become a problem. 'The next thing we know, people will be suggesting we put up a grandstand so that people can watch the nudists,' said one Telscombe resident.

Things came to a head in 1969, when a report dated 9 October 1969 in *The Evening Argus* highlighted the increasing pressure to get nude bathing banned from the beach. To become effective, a new proposed by-law had to be approved by the Home Office. A spokesperson from Telscombe Cliffs Ratepayers Association had said, 'The beach is still a tramping ground for perverts and homosexuals.' Mr Ernest Stanley, chairman of the South Eastern Region's Central Council for British Naturism, countered in a press statement: 'The Home Secretary's decision is both an endorsement of the representations made by our association and an acceptance of the Country Commission's recommendations.' The recommendations he referred to set out by the Country Commission were that, in coastal areas, the needs of those who 'seek solitude' should be provided for.

On 14 November 1969, *The Brighton and Hove Herald* announced that the Telscombe beach struggle seemed to be almost over – and that the nudists had won. The revised by-law came in for criticism. 'Practically useless,' complained Mr Stanley Lindeman, Chairman of Telscombe Ratepayers Association. 'I don't think it makes any progress,' he told *The Herald* reporter. 'We are back to square one.' The by-law now proposed by the county council was the original proposal amended. It read: 'No person shall in any street of public place, to the annoyance of any person, wilfully and indecently expose his person.'

Mr Lindeman's point was that that this was the law anyway. 'We don't think it goes far enough,' he said. 'We wanted a complete ban on nudists.' He agreed it might make

Telscombe Beach. (© Simon
Carey www.geograph.org.uk)

some of the 'undesirables' more cautious but it wouldn't get rid of them and it would be difficult to enforce in any practical way. Any case of genuine annoyance would have to be proven, and residents might be embarrassed to give evidence. It would be one man's word against another.

It was felt that the Home Office had compromised with the objectors, and Mr Lindeman concluded: 'I think the nudists have got the better of this deal.'

Brighton became the first major town to have its own dedicated nudist beach in 1979, its main advocate being Councillor Eileen Jakes. On 13 July 1979, *The Brighton and Hove Gazette* published a full spread of photographs of naturists enjoying the sun on the beach near Southwick power station with their article 'A bare it all haven for naturists'.

23

IT'S GOOD TO BE GAY

The seventies was a decade of increased political awareness, opposition to nuclear weapons and support for environmental issues, an oil crisis caused by Middle Eastern embargoes and the accompanying economic recession, all culminating in the 1979 election of the Conservative Government under Margaret Thatcher. Some LGBT people were still cautious about 'coming out' in spite of Acts that were supposed to protect them.

The Gay Liberation Front, founded in America and started here in 1970, said that gay was good and that 'coming out' was to be the basis for a new movement. University students, and gay men and women formed the Sussex Gay Liberation Front in 1971. Gay Liberation organised the first open gay dance at Kensington town hall in London. The first major UK meeting of the Sussex Gay Liberation Front was held at the Marlborough in 1973, the same year that the American Psychiatric Association was successfully pressed by Gay Liberation to remove homosexuality from their 'list of diseases'.

LESBIANS REBEL

Germaine Greer proposed the uncensored expression of fantasy was necessary for what she described as 'Pussy Power'. Greer believed that female erotic desire would provide a subversive force against patriarchal repression. At this time, some lesbians had relationships with women because they were sexually attracted to – and loved – women. Others saw lesbianism as a political issue, a rejection of men both sexually and socially. Although their views may be seen, in hindsight, as extreme, there was a climate of male bias in the legal profession at this time, much deplored by women's groups and rape crisis centres. Lesbians believed that a woman could 'choose' to love another woman, and that homosexuality was not necessarily congenital.

CORRECT MORAL VALUES

In April 1972, *The Argus* reported that the case for sex education in schools to be given by specially named married doctors was backed up by the BMA's junior members' forum on 9 April. The implication was that only married medics were capable of imparting the correct moral values on the young, and education about alternative lifestyles was still some distance into the future. Bookshops were frequently asked to ban 'dirty' publications; for example, one incident reported by *The Argus* involved an organiser

of the 'Festival of Light' aided and abetted by broadcaster Malcolm Muggeridge, their combined purpose being to halt the moral and spiritual decline.

This was a time when the reformer Mary Whitehouse was at her most energetic in opposing pornography and what she saw as irresponsibility in sexual matters; an irresponsibility that, according to Whitehouse, threatened the very core of our society. On the positive side, by the end of the 1970s, Holloway Prison began to take a more tolerant stance towards lesbian relationships among the inmates.

A PRISONER OF WAR!

An accused man asked for his charge sheet to be changed in court – because he planned to become a woman and had just started medical treatment. The man told Brighton Magistrates Court he was undergoing a sex change and he applied to have the charge sheet changed to the new female name. According to *The Argus*, dated 6 April 1972, the twenty-six-year-old man was from Marine Square in Brighton. To its credit, the court agreed that the name should be changed and a plea of guilty for being drunk and disorderly was entered. The police had apprehended the suspect, wearing women's clothes and with a handbag, in Preston Street, and were told 'I am a prisoner of war.' (Possibly this statement was a metaphor for being a transgendered person in a hostile environment.) A fine of £5 was ordered and forfeit of the £10 bail.

NO BUSINESS BEING IN SHOW BUSINESS?

In *The Argus* of 28 April 1972, a letter was published from Brian Ralfe, who, during the previous months, had been much criticised. His crime? Standing for election for the Labour Party and – at the same time – being a drag queen. One councillor had accused Mr Ralfe of using the election for publicity purposes and making a mockery of democratic procedures.

In his letter, Brian Ralfe pointed out that this was the third time he'd stood for local election, while he'd only been in show business for eighteen months. For the past twelve years he'd been a stalwart Labour supporter and he found the councillor's accusations both insulting and unnecessary. He had been with Kemp Town Labour Party for nine years and only resigned in 1970 because he disagreed with its extreme left-wing attitudes. During that time, Councillor Clarke had been only too pleased with his work and staunch support for Dennis Hobden (1920-1995), who had succeeded to office, becoming the first Labour M.P. in Brighton and in Sussex. 'Many people obviously agree with my stand as no problems have been experienced in obtaining signatures on my nomination papers,' said Mr Ralfe. 'After all, what is wrong with being a drag artist?'

A HOMOPHOBIC DOCTOR

In 1975, a letter published in *The Argus* from John Montgomery of Kensington Place, Brighton, cited the case of a doctor alleged to have left Britain because 'there are homosexuals here'. 'What an ignorant doctor,' said Mr Montgomery, 'he will, by now,

A drag queen at Pride, 2004. (© www.aspexdesign.co.uk)

have discovered in America, Austria, India, Japan, Scandinavia, or wherever he went, that homosexuality is not a trendy cult but a universal condition – and no more unusual or extraordinary than having fair hair or blue eyes.'

Mr Montgomery pointed out that homosexuality wasn't an anti-social condition, listing a number of reasons, for example, they very seldom broke up families and were generally hardworking and loyal besides contributing much to civilisation. He spoke out against bias and misinformation, saying it was unhealthy to attack minority groups, Quakers, Jews, immigrants, etc. He also spoke up strongly for individuality.

'Minority groups are tired of having to carry burdens for the guilt-ridden majorities,' he said.

JOB PROSPECTS IMPROVE

In a report in *The Argus*, dated 29 January 1975, the following statement appeared: 'A homosexual who applied for a job as a teacher in a West Sussex school would be considered on the same basis as any other applicant, provided no misconduct had taken place and there was no risk to children or students.' Homosexuals were already employed on the payroll with the same rights and the same job security and prospects as everyone else. One very positive change was that all local schools had been acquainted with the need to discuss with the children issues of homosexuality within the context of human relationships.

THE LAVENDER LINE

In 1975, The Brighton Lavender Line, forerunner of The Brighton Gay Switchboard, started at the Open Café in Victoria Road with just one 'phone, one of its volunteers being Clemence Dane, the novelist (see Chapter 6).

MR NIMROD PING – ONE OF BRIGHTON'S FAMOUS GAY CHARACTERS

Mr Nimrod Ping, who later ran Pride, has been one of Brighton's key gay characters and was frequently mentioned on Sarah Kennedy's Radio 2 show. Geraldine Curran remembers how he managed to persuade the council to extend opening hours for clubs in Brighton, which once closed at midnight.

Geraldine worked with Nimrod Ping at the Brighton Planning Department where he was an architect in the late seventies. They shared their opinions of hair colourants. 'Nimrod grew one long nail on his little finger as a pointer for when showing plans,' she says, 'and he had a solid gold tooth in the front of his mouth which dazzled you.' She says there was something of the 'Captain Hook' about him and that he wore a big, gold earring in his left ear. 'Apparently that was one way of announcing yourself to other gay men, as well as the signet ring on the little finger.' Geraldine adds: 'Nimrod Ping used to go out with a female friend of his to clubs and bars and they would bet on a packet of peanuts who would get the man they both fancied.'

Mr Ping died in 2006. In his biography on the Canadian gay website, 'Life on Brian's Beat' (http://gaynorfolk-net.norfolk.on.ca), his brother Peter is quoted as saying, 'He

was the kind of guy who would say, "Why have a light bulb when you can have a chandelier?" He had enormous determination and lust for life. He would set himself targets and then give himself rewards when he achieved them. He had booked a trip to Australia to reward himself for completing his MA. His enthusiasm for life was wonderful. He will be sorely missed.'

24

PROBLEM PAGES OF THE SEVENTIES AND EIGHTIES

Problem pages of past decades provide fascinating insights into everyday concerns. Agony Aunt columns began regularly publishing gay-related problems. These are some letters written to Agony Aunts in the 1970s and 1980s.

NOT MY DAUGHTER!

A woman wrote to *The Argus* and her letter was published on 21 January 1975. Her daughter had a crush on an older girl at school, a prefect on whom she doted. The young girl was just fifteen, but her whole life centred round the admired older girl. 'Although I hesitate to say this, it's almost as if she's in love with her. One reads so much about relationships between the same sexes these days that I am desperately worried my daughter is a little abnormal in this respect.'

The woman was unable to discuss her concerns with her husband who was away on business, and was afraid to talk to her daughter. This was a chance, one might think, in this decade of supposedly increased tolerance towards gay people, for the Agony Aunt to reassure the woman that if her young daughter had lesbian tendencies, she should be supported, and not made to feel as though she was abnormal or unnatural. Instead, she simply pointed out that schoolgirl crushes are a natural phase of growing up. 'In my day nobody suspected a girl might have lesbian tendencies, which, clearly, is the thing that is worrying you.'

She advised the mother to ignore the subject and trust that her daughter would 'grow out of the phase fairly soon'. After that, her affections would be transferred to someone of the opposite sex. Regrettably, there was not one positive piece of reassurance, guidance or advice to support the writer of the letter in the event that her daughter actually was a lesbian.

IS THE MAN I LOVE GAY?

In *The Argus* on 12 September 1984, a young Brighton divorcée with two children wrote to the paper's Agony Aunt about a man she had met. They were compatible, with a similar sense of humour and they had fallen deeply in love. The man revealed to her that he had had a homosexual relationship when he was younger. She was devastated and scared to commit in case he suddenly decided he was homosexual after all and abandoned her.

The Agony Aunt explained that many young, basically heterosexual men experimented with homosexuality in their youth – some found it wasn't for them and moved on to becoming heterosexual, others became bisexual and some decided that they were definitely homosexual. Sensibly, Agony Aunt, Georgette Floyd, suggested the young divorcée should seek help from the Marriage Guidance Council. As most people know, the Marriage Guidance Council is now 'Relate' but they were willing in previous decades to help people in unmarried relationships.

SCARED TO ASK

A young divorcée with a ten-year-old child wrote to *The Argus*' problem page. Her letter was published on 28 July 1986. The previous year, a young bachelor had moved into her road, and for the first four months, the two of them simply exchanged 'hellos'. Then they began to become real friends and spent a lot of their time in each other's company. He was kind and thoughtful, everything she longed for in a man, and she started to fall for him.

The problem was he didn't seem interested in moving the relationship forward and she wanted to know whether she should make the first move. She was cautioned to wait till she knew him better. There seemed a possibility he might be gay, and making a move on him might spoil the friendship and scare him away. Today, it's hard to see why she made such a big deal out of it, and didn't simply ask him. After all, their friendship had been going on for some time. But this was the eighties, and the accepted wisdom among some people was that men should make the first move – and women should wait to be chosen!

25

NO GROWTH WITHOUT PAIN

During the eighties, notable gay venues were the Marlborough, the Aquarium and the Queen's Head. When Mr Chris Darnell took over an Irish pub, the Aquarium, in 1985, he decided to transform it into a gay venue. Jamie Hakim of *3SIXTY* magazine, April 2005, quotes Chris Darnell, who was known as 'Maggie' to his friends: 'I was horrified when I first walked in and I suppose so were the old regulars. They'd all moved on within a month – only because I actually cleaned the place.' After a shaky start, by around August 1986, the pub began to prosper and it's claimed it became Brighton's top gay pub.

After this, Mr Darnell moved on to repeat this success by taking on the Queen's Head.

Another story from Jamie Hakim's article concerns the Marlborough, in which Chris Darnell was also involved. Gary, a young patron who'd recently moved to Brighton, said, 'The place was really intimidating, as the windows were all boarded up. I stood there terrified, surrounded by a sea of scary leather men, until I overheard two of them discussing how to make a soufflé rise.' After that, Gary felt okay.

Ordinary Brighton people were becoming more open about problems in respect of gay issues, but there were still many restraints in social relations. Prejudice against gays was heightened by the onset of AIDS, dubbed 'The Gay Plague' and religious dogmatists insisted it was sent by God to 'punish the perverts'. Ron Forrest remembers that, in the eighties (he can't remember the exact year), he marched from St Peter's Church along Western Road with boxes, collecting money for AIDS. 'You couldn't afford to ignore it,' says Ron, 'and it became political because the lesbians were there and they wanted to be recognised.'

A 'NEW AGE' VICAR

Father Holdroyd was the vicar of St Bartholomew's, Brighton, and he achieved instant fame when he hit the headlines by urging his parishioners to vote anything but Tory in the next election. The report, in *The Brighton and Hove Gazette*, dated 3 October 1980, did not expand on the Father's reasons for boycotting the Tories, but it did quote his views on sex and homosexuality. He was a heterosexual man and a vicar but had adopted a 'live and let live' philosophy.

He said it was good to live in a New Age place like Brighton, with broadminded attitudes, a town that allowed the nudist beach and the previous year's Campaign for Homosexual Equality Conference. 'Sex is as important as eating and drinking,' he said.

Brighton shops cater for all tastes!

'In fact, it's probably more important, because it involves other people.' In the following quote about homosexuality, his wording, especially the use of the word 'propensity' sounds a little quaint today, but it does indicate that a more tolerant and understanding attitude was beginning to be adopted among certain members of the clergy. 'People with that particular propensity,' he said, 'have a very rough time from society. I think the Church should do more to help them.'

Father Holdroyd confirmed he had never been asked to bless a homosexual 'marriage' (*sic* – there was, of course, no formal civil partnership ceremony until 2006 in the UK and the Father may have simply meant the blessing of a 'homosexual union') but he said he would take every case as it comes. 'I don't believe in permissiveness but there is a great turmoil in relationships at the moment. I believe that is inevitable and there is no growth without pain.' Father Holdroyd concluded by saying his ambition was to become a more holy and loving person.

LEGENDS BAR – JUST A RELAXED PLACE TO GO FOR A QUIET DRINK!

A new bar was to be opened in Brighton and it intended to make a big splash. It would be called Legends and would be a fashionable meeting place for Brighton residents, with a bar and informal diner decked out in pink and green.

Legends Hotel and Bar, Marine Parade, photographed in 2006. Permission of the management.

An article in *The Argus*, dated 17 August 1986, described the plans for the new bar. It would occupy premises previously known as 'Rosie O'Grady's' on Marine Parade opposite the Palace Pier. Although promoted as a fairly laid-back kind of place, the new owner, David Rimmer, intended for Legends to be noticed. (David Rimmer also owned the Pink Coconut, which had opened three years previously.)

A 26-Watt laser, believed to be the biggest laser in the world, was to inscribe the name LEGENDS in the night sky between the two piers. There would be a ball-shaped fountain on the ground floor and mirror balls hanging from the ceiling. But Mr Rimmer stressed that this would not be a late-night disco affair. 'We hope to attract people who do not want to stay out late at night,' he said. Also, you had to be over twenty years old and smartly dressed.

Legends Bar, high enough to command stunning sea views, is now part of the Legends Hotel complex, claimed to be Brighton's largest gay hotel. But you don't have to go home early any more! In addition to Legends Bar, there is also The Basement Club where you can dance till 4.00 a.m. The address is 31-32 Marine Parade, Brighton.

SECTION 28

Section 28 of the Local Government Act 1988 was an amendment to the United Kingdom's Local Government Act 1986 which stated that a local authority 'shall

not intentionally promote homosexuality or publish material with the intention of promoting homosexuality.' It should not promote the teaching of any maintained school of the acceptability of homosexuality as a pretended family relationship. It caused teachers to be afraid to counsel about gay issues for fear of losing state funding and LGBT support groups in learning institutions closed across the UK.

There was an immediate angry backlash from the LGBT community. The Brighton Lesbian Action Group had already met to discuss the forthcoming Act in February 1988 but their efforts came too late to be effective. Their campaign continued, however, with regular marches between Hove and Brighton town halls, and from this thrust came the birth of an exciting new project, *Brighton Ourstory*, in which LGBT people were interviewed and their experiences and viewpoints recorded.

Section 28 was enacted on 24 May 1988 and repealed in Scotland on 21 June 2000 and in the rest of the UK on 18 November 2003.

26

A FIRST DECADE OF PRIDE

1991-1999

There were nine Prides in the 1990s (also several sources indicate a single Pride in 1973, although it was not possible to find any newspaper references to this event). In the beginning, the events were far from the joyous celebration we enjoy today. The early forerunners of the Pride we now know and love were more like demonstrations than celebrations, and were beset by problems, practical, financial and political. There was a furious backlash evident in newspaper reports and readers' letters, revealing a level of intolerance that must have been overwhelming for the gay and gay-friendly participants.

FIRST PRIDE, 1991

Although the first Pride is often quoted as 1992, Dani Ahrens, in her letter to *The Argus*, dated 29 August 2006, points out, 'Fifteen years ago may be ancient history to today's *Argus* reporters and Pride trustees, but there are still plenty of us around who did the hard, exciting work of organising the first Pride march in 1991, not 1992.' The 1991 march went from Hove town hall to Brighton town hall.

The march was an angry local campaign against Section 28 (detailed above), implemented by the Tory government three years previously. There was anger among the LGBT community at the trivialisation of their so-called 'pretended' family relationships and what they considered to be the legitimisation of homophobia in order that the government might secure a few votes. The £5,000 grant to support disabled access at the event met outrage in the newspapers. Dani Ahrens concludes in her letter: 'The real story of Brighton Pride is an inspiring one. It's not a rags-to-riches story – it's about the energy, passion and hard graft our community has put in over the years.'

PRIDE, 1992

Many people believe the Pride festival in May 1992 was held at The Level, although this is hotly disputed by Dani Ahrens in her letter in *The Argus* of 29 August 2006. The Pride march went to Preston Park and the money provided to support disabled access provoked outrage in *The Argus* letter column. 'We learned a big festival in the park is not viable without financial support from the gay business community or from the council,' said Dani Ahrens.

Brighton Seafront. (© Janet Cameron)

Again, this was a political event to protest against the government's Section 28. It was organised by a community group called Pink Parasol, but there were some fun events planned, as reported by Adam Trimingham in *The Argus* of 14 May 1992. This proved, according to Mr Trimingham that 'the gay community is sufficiently sure of itself to host a festival, including a Queer on the Pier Day and a Lesbus.' Gay activities were to be run throughout the ten-day event.

A FRENZY OF HATRED

In the weeks preceding the Pride festival, *The Argus* was inundated with angry letters from those who condemned the £5,000 allocated by the council to support the gay events. One letter, on 18 May, pointed out that the contribution made by the gay community culturally, in taxes, socially and economically, proved they were not a favoured minority. Another correspondent in *The Argus* of 20 May of that year remarked that he begrudged public money being spent on 'frivolous pleasure'.

The Argus' reporter, Adam Trimingham, wrote for the 21 May edition, arguing against bigots' 'rumblings and grumblings over the Festival'. Mr Trimingham agreed there was a valid argument as to whether the festival should receive public money. What he disliked was the 'distinct stench of bigotry and name-calling'. Shockingly, Mr Trimingham revealed that, since writing about the festival, he had received a poisonous

letter hoping his death from AIDS would shortly be announced in the obituary column. Such letters were usually unsigned or signed with false names, said Mr Trimingham. The reporter pointed out that gays in Brighton and Hove contribute greatly to the town, in almost every aspect of life. 'Bigots should stay at home and indulge their pet hobbies, such as sticking pins in wax dolls . . . Meanwhile I shall not be there but I hope those involved have a gay time in every sense of the word,' concluded Mr Trimingham.

PINK PARASOL IN RECEIVERSHIP

This wasn't the end of the matter. According to *The Argus*, dated 25 February 1993 (the following year), Pink Parasol, the organisation running the event, found itself in financial difficulties. Later, it went into receivership, allegedly owing £4,300 and causing further criticism from the general public. There were accusations of 'poor judgement' and an 'ill-fated event.' Pink Parasol blamed the recession and the fact the event had not attracted as many visitors as expected.

Spokeswoman Dani Ahrens said, 'We are sad it was not able to cover its costs. It was, nonetheless, the best attended lesbian and gay Brighton event ever seen.' A letter in *The Argus*, dated 25 February 1993, from Dani Ahrens, stated that the £725 owed by Pink Parasol to Brighton Council was for re-turfing part of Preston Park. 'We were assured by council officers that Preston Park was left in very good condition after the Pink Parasol event. There was no litter and no damage. The £200 deposit paid to the council was returned to us in full,' she said.

PRIDES 1993, 1994, 1995

Pride 1993, once again, was run by a handful of dedicated individuals and held in Queen's Park. Pride continued to make a loss, as there were no sponsors to help fund the event. People had yet to see the potential for business input and eventual expansion. In 1994, Pride was held on The Level by the determined individuals who refused to buckle to their dissenters and worked to keep the gay community alive. If it hadn't been for their endurance in spite of local hostility, businesses would not have decided to become involved later. 1995 was the first year that Pride managed to secure decent sponsorship, with a few pubs and clubs willing and able to help promote the event.

PRIDE 1996 – A MARDI GRAS FLAVOUR

The Independent of Friday 17 May 1996 mentioned 'The Alternative Miss Brighton' catwalk event to take place that evening at the Big Top, Preston Park. 'Glitz, glamour and outrageous camp,' says the report. 'Entrants should make Priscilla Queen of the Desert look like a dowdy old housewife.' But there was a stipulation: 'Judges will also be looking for candidates with more interesting ambitions than an ersatz interest in charity work and young children.'

Pride 1996 took place on Saturday 25 May and was reported the following Monday in *The Argus*. Gay men and lesbians turned on the Mardi Gras style, as ten colourful

The Peace Statue.
(© Janet Cameron)

floats moved from the Peace Statue on the seafront to Preston Park. A bright blue sky partly compensated for the downpour on the Friday. People were disappointed, as it had spoiled a candle-lit vigil especially for AIDS sufferers.

The paper commented on a 'scantily-clad Batman in a posing pouch'. At Preston Park there were stalls, cabaret and a disco and, to the delight of Alan Grey of the organising committee, 10,000 people attended. Alan Grey said, 'It was a wonderful day. There was a real Mardi Gras flavour to it and it was bigger and better than ever.' Mr Grey was pleased that people had come from all over the country for the event. Someone had even travelled from Key West in Florida – just to be at Brighton's 1996 Pride Event.

PRIDE 1997

The Argus of 31 July reported that Pride 1997 would be held on 9 August. Parade floats publicising major gay pubs left the Peace Statue, wended their way via Preston Street, Western Road and Old Steine, to arrive at Preston Park by one o'clock. The main attraction for the day was chart star Lisa Stansfield, whose song 'All Around the World' had been a No. 1 UK hit in 1989. Lisa Stansfield had taken part in a charity disc Red Hot & Blue in the early nineties, to support AIDS research when government funding was insufficient.

PRIDE 1998

By now, Pride was becoming much more inventive and adventurous. *The Argus* report by Jakki Phillips on Monday 10 August 1998 was a fine, two-page spread with many photographs. The Brighton gay club 'Revenge' manned a double-decker bus from which its passengers fired water pistols into the crowd, soaking everybody within range. Gaywatch, the gay social network, featured young men in Pamela Anderson wigs and low-cut swimsuits. Accolades from the police organisers for being a thoroughly trouble-free event were numerous. There was some congestion on the roads, but nobody seemed to mind – 'maximum congestion on the roads, maximum impact on the ears and eyes'. Local artists supplied music at the park, such as Reckless and Venus' Love Child – and Bucks Fizz turned up too in some tight, shiny, purple outfits. An extra feature was an interpreter signing the words of the songs.

QUOTATIONS FROM PRIDE 1998 (*THE ARGUS*, 10 AUGUST)

Jessica Banks, musician (24): 'I have a friend who is deaf but she's on her holiday at the moment. She'd have been really pleased to have seen the interpreter and I think it's a wonderful idea. They should have them at all concerts.'

Sue Nichols, organiser of Brighton Pride: 'The march is about politics and equality and I think people understand that when they see the banners and the leaflets being given out.'

Simon Fanshawe: 'It's great to see young and old people alike laughing and joking with drag queens and enjoying the spectacle of the parade. A few years ago it would have been frowned on. Now people simply think it's all a bit odd but interesting enough to come along and see what it is all about.

Sister Teresa Walton, Royal Sussex County Hospital: 'I think this could be the busiest weekend we've had in the Accident & Emergency Department . . . but most of the weekend's casualties have been minor sunburns or dehydration.'

Leo Sayer: 'They only asked me last week if I would be the surprise guest at Pride. Of course, I jumped at the chance of spending a day in the sunshine with lots of happy, smiling people.'

Venus' Love Child: 'I love singing at Pride but this year there are so many people – which is a bit terrifying.'

PRIDE 1999

This Pride was special, with an extra delightful celebration – weddings. Three couples responded to an advertisement and decided to get married at Pride, including Louise and Fiona, both aged 23. 'What better place is there?' said Louise to *The Argus* reporter. An

account of the day was published on Monday 16 August 1999. The Revd David Miller of the Fellowship of Faith, said, 'It is a rite of blessing rather than a wedding service. Couples get a certificate, which is proof for them. It is a commitment for both of them and shows that they are in a stable relationship.'

Around 60,000 people turned up to see the twenty floats. The first float was Colourguard, a Brighton dance troupe, and Club Revenge took care of the disco music. One of the main attractions was an outrageous '40' float featuring a naked man under a shower, while people danced around him. This feature was sponsored by the Avalon Guest House. There was a sudden shower – apart from the one on the Avalon float – but 'nothing could wash out the celebrations'. There were local bands, Toucan and Metronome, at the park as well as dance stars Suzanne Rye and Soraya UK and tribute bands, Steps and ABBA. As a final touch, two young, male, mime artists managed to arrange themselves into a male version of Rodin's masterpiece, 'The Kiss'.

The Princess of Pride was a twenty-four-year-old who had never attended a Pride parade before. Jules Payne of Meeting House Lane had heard about Pride and how good it was. 'I am lucky to be Princess of Pride, which is amazing.'

27

MAKING CHANGE HAPPEN

In spite of the many positive aspects of Pride's progress from year to year, there were still many instances of ignorance, bigotry and exploitation.

A DIFFERENT KIND OF OUTING

A case appeared in *The Argus*, dated Monday 8 June 1992, reported by Paul Bracchi, and concerning an AIDS charity official, Bernard Jay, who was forced to resign from 'Brighton Cares'. *The Argus* had previously published revelations of Mr Jay's £26,000 per year salary paid from the proceeds of fund-raising shows back in February that year. Jay had pretended he was giving his time freely, a cynical claim since his salary was twice the money awarded to victims. The next show, it was promised, would be organised by a Brighton-based producer free of charge – and Mr Jay left the country.

STRUGGLE FOR A PINK CHARTER

Adam Trimingham's report in *The Argus* of Friday 5 June 1992 began: 'Gays Push for their own Pink Charter'. This was a launch with bite, as LGBT groups combined resources to launch a campaign with a firm manifesto of demands. 'We should have the right to be proud of our sexuality in public places,' said the Brighton Outrights campaign. Events, like the Pink Parasol Carnival held in Brighton the previous month, needed their rightful share of public funding.

The campaign called for positive representation of lesbians and gay men in the media and rights to work without victimisation. There should be an end to violence and discrimination against them, including the right for same-sex couples to raise children. Sex education should inform children about all sexual options and homosexuality shouldn't be regarded as a 'mental-health problem'. Lesbian and gay youth groups should be supported and funded. Lesbians and gay men were, said a spokeswoman for the groups, angry that their sexuality was either ignored or used as an excuse for the denial of their rights.

'While celebrating our differences, we are united in our need for respect,' she said.

THE TERRENCE HIGGINS TRUST HIV/AIDS BOOK

There was also much ignorance and fear among the community about AIDS. An advertisement in *The Argus*, dated Friday 5 June 1992, promoting a new publication,

The Terrence Higgins Trust HIV/AIDS Book, to be published the following 25 June, claimed: 'Sadly there are still people about who think it is dangerous to talk, eat or drink with a person who is HIV positive.'

A BREACH OF CONFIDENTIALITY TOWARDS A CROWN WITNESS

A number of articles appeared in *The Argus* in the summer of 1992 regarding an alleged breach of confidentiality by the police. Nineteen months previously, a gay barman had been stabbed in his Brighton flat. A friend of the man revealed his homosexuality to the police at that time, in strict confidence. When he later appeared in court on his own account after being attacked by another man, his statement from the original court case was revealed to the court, even though nineteen months had elapsed since the murder of the gay barman. Originally, the statement was handed to the defence lawyers by the police in the murder case, as required by law, and it was claimed the document had later been passed on through Lewes Prison.

According to Alex Bellos in *The Argus*, dated Wednesday 10 June 1992, gay people said they would not be willing to fully cooperate with police enquiries in the future due to this breach of confidentiality. How, they asked, could a homosexual man's confidential statement to police be used in a court case to reveal his sexuality? They would be 'more circumspect in the information they gave to the police in future.' Brighton Outrights, the group for LGBT rights, conducted a survey that showed that LGBT people were losing trust in the police, and that 24 per cent of women and 27 per cent of men had been physically attacked in the last year, while 56 per cent were verbally abused. Only half would now report an attack to the police.

The Chief Superintendent said police did not release the statement to the defence in the other case, but that the defence lawyer in the original case had requested a copy of all unused material. The police, by law, had to supply this documentation. When the second case was heard, the defence produced a photocopy statement from the unused material served on the defence lawyers.

The Chief Superintendent expressed his sadness that, after trying to help the gay community, the police should be unjustly criticised. The Brighton Police and Public Sub-Committee said the Home Office would be approached to express concern that the breach of confidentiality had occurred in spite of legal police behaviour and a cooperative witness. In *The Argus*' opinion column, some readers expressed sympathy for the police under the circumstances.

DIVISION AND THE CHURCH

The Argus of 6 May 1992 published a letter from Mr Arthur Law regarding the refusal of the Mormon church to join other church groups supporting Brighton Lesbian and Gay Pride Festival. Mr Law said we had moved on from the Dark Ages, when the ecclesiastical courts buried lesbians and gay men alive. 'Tragically, some church leaders continue to bury us alive in intolerance, preaching a gospel of shame. It is that shame that contributes to the fact that one third of all lesbians and gay men attempt suicide before the age of fifteen,' said Mr Law, concluding that it was outdated prejudice that needed to be buried, once and for all.

In the same issue, Simon Barnes wrote, 'I have seen too many gays who have had a tortured existence because they married against their nature, with the whole family suffering as a result.' Ron Forrest cites just such a case: 'In Devon Place in Edward Street, a homosexual man was discovered in mutual masturbation with a man who was married, but bisexual. The case ruined the bisexual man's marriage,' says Ron.

Two weeks later, a gay demonstration of around fifty people was planned at a house in Richmond Road protesting against anti-gay signs painted by the owner, condemning homosexuality. Fortunately, although the signs had been there for some time, the police removed them thirty minutes before the start of the demonstration.

A DESPERATE PLOY

An incident reported in *The Argus*, dated 19 February 1993, drove two gay men to desperation to save themselves from a 'gay-bashing' mob, the ugly new term that replaced the former term, 'queer-rolling'. The terrified couple from Brighton were viciously attacked on a bus, so one of them, with great presence of mind, pretended that his partner, by now soaked in blood, was suffering from AIDS. Mr W., the thirty-six-year-old man said, 'I have no doubt that if I hadn't told the men who attacked us that my partner had AIDS, then we would have taken a worse beating.' Fortunately, thanks to his quick thinking, the man's partner did not need hospital treatment.

But although the ruse had worked, the ordeal was not yet over for the two Brighton men who lodged an official complaint against the police at Eastbourne. The men had been kept for eight hours without charge, and also waited three hours before the police surgeon could examine them. An officer called them 'queers'. The police eventually dropped their charges against the men and did not offer evidence at the Magistrates Court at Eastbourne.

The three attackers were charged with a 'breach of the peace', agreeing to be bound over for a year. 'We were innocent victims of a violent attack,' said one of the victims. 'I didn't believe it when we were charged.' Sussex Police 'declined to comment' but said the men's complaints were being investigated.

SHAME ON CILLA BLACK

A gay protest about the omission of gays on Cilla Black's *Blind Date* show elicited a response from D. Barker of Brighton in *The Argus* of 3 March 1993. 'Surely they should be grateful to be omitted from the awful Cilla Black spectacle,' said D. Barker, who felt that heterosexuals were grossly misrepresented on the show. 'Do we really behave like this?' s/he says, concluding that gays should be happy not to be on *Blind Date*.

GAYS EXCLUDED FROM THE MILITARY

Gay campaigners were outraged because the latest bid to end the exclusion of homosexuals from the armed forces was defeated in the Commons. M.P.s had voted 188 to 120 to maintain existing regulations that prevented homosexuals from serving. It was, said the campaigners, an action against civil liberties.

The report in *The Argus*, dated 10 May 1996, recorded the reaction from the spokesman for gay rights group Outrage, Mr Peter Tatchell. Mr Tatchell's main criticism was for the Labour Party. 'This vote underlines the continuing second-class legal status of lesbians and gay men and it perpetrates discrimination against them,' he said. 'We are appalled that Tony Blair has expressed his support for retaining the ban on gays in the military. Many lesbians and gay men have supported Labour because the party has previously opposed discrimination.'

Crawley's M.P. Nicholas Soames, the Armed Forces Minister, told the paper that the government's ban was not based on a moral judgement. He said that people of the same sex lived closely together in the armed forces and needed to have absolute trust in each other. Those conditions meant the potentially disruptive effect of homosexuals had to be excluded.

Although, at the time of writing, there are still problems in the United States for homosexuals in the military, opposition has been eradicated in many countries including the UK, and gay and lesbian soldiers marched at London Pride 2009.

PROBLEMS AT WORK FOR LESBIANS AND GAY MEN

In the 1990s, the newspapers continued to report cases of discrimination against lesbians and gay men at work. Many LGBT people kept their sexuality a secret for fear of losing opportunities at work, or of being picked on by their workmates. One young teacher in the 1990s tells how she maintained the pretence of heterosexuality, convinced she was the only lesbian on the staff of her primary school. Fearing for her job security, she was anxious not to be compromised by being seen with her partner by someone from school.

Sussex County Council's lesbian and gay staff complained that they suffered taunts and harassment by colleagues, and discrimination by being overlooked for promotion. *The Argus*, dated 26 April 1996, reported that gay staff had asked for County Hall's equal opportunities policy to be rewritten, providing them with greater protection. Brighton councillors said staff were planning for local government reorganisation and did not have time to draw up new guidelines. The council asked that the victims should wait.

The council's head of paid services, Cheryl Miller, said the whole policy would be looked at again by the new county council due to sit in a year's time. Equalities officer for UNISON R. Johnson said that if the policy were developed to show the council's commitment to their gay staff, then such cases would not arise in the first place. He also pointed out that the current policy, which dealt with prejudice towards black people and women, 'only makes passing reference to homosexuals'. The council should make it clear that people could not get away with discrimination and harassment. Mrs Miller replied that it would take time to develop a suitable policy and currently staff could not do it justice.

The Argus of 2 May 1996 reported that a group had been formed in Brighton especially for gay and lesbian teachers. The article claimed teachers in the area were living in fear and isolation. 'Dave' of Brighton Gay Switchboard had received a number of calls from gay and lesbian teachers who were suffering problems at work, and he arranged a meeting. Around fifteen teachers turned up to talk about their problems.

Dave, who had been a teacher in a Brighton primary school for eleven years, said, 'I'm out to my colleagues but not to my pupils or their parents, because I don't think that's professionally a necessity.' He explained that many homosexual teachers felt isolated because they were afraid to 'come out' to colleagues, some of whom might be homophobic.

Many gays and lesbians were concerned about reactions of parents to their sexuality. Some parents were afraid children might be influenced by their teachers, and become gay themselves. 'But that's a myth – you can't be influenced to become gay, you just are inside.' Other problems facing lesbian and gay teachers were dealing with anti-gay remarks or helping pupils experiencing problems with their own sexuality. Dave felt the meetings were very helpful. 'We also meet to have fun and a good time, not just as a reaction to what society is like,' he added.

ROW OVER LOTTERY CASH FOR GAY ART

A £4,500 loan for the Brighton-based 'Gay and Lesbian Arts and Media' to promote gay art on the Internet caused controversy, according to *The Argus* of 13 June 1997. Shirley Wrigley, a Brighton councillor said she had nothing against gays, but that there were other projects more to the advantage of the community. 'I would prefer to see money spent on helping deprived children.'

The GLAM website was to be implemented by Labrys Film and Video Productions, the aim of which was to promote the work of gay painters, photographers, film-makers, cartoonists, sculptors, composers and actors. The grant was one of thirty-two made to arts projects in Brighton and Hove.

Arguments against funding for gay projects can be seen as unfair, frequently pitched to appeal to negative emotions and centring on accusations that other, more deserving cases are suffering as a result. The arguments of 'less deserving than . . .' were less likely to be put forward to combat other types of adult arts or educational funding.

28

INTO THE MILLENNIUM

The 2001 Census showed that Brighton and Hove had the highest proportion of same-sex households, estimated at 1.29 per cent of the population. The 2001 population, according to the census, was 134,293. During the nineties and into the Millennium, the combining of resources and efforts was beginning to yield results. Here are some of the positive outcomes of those efforts.

THE EARLY SUSSEX BEACON AND GEORGE MAYES

A report by Rosemary Edwards in *The Argus*, dated 8 August 1992, tells how a chance meeting with another nurse six years ago changed the life of thirty-seven-year-old senior charge nurse, George Mayes. The other nurse worked at St Stephen's Hospital in London and she told George there were difficulties getting staff to work at the AIDS/HIV unit. George Mayes felt immediately that this was a good opportunity to use his training with cancer patients to benefit AIDS/HIV patients – and so his life changed.

At the time of *The Argus* report, George had become director of The Sussex Beacon, the new hospital built in Bevendean, Brighton, to care for people with AIDS and AIDS-related conditions. A rush of applications, 120 for only fourteen jobs available, proved how much progress had been made to dispel the ignorance and fear that surrounded the disease since George Mayes had talked to the London nurse six years previously.

George Mayes explained how stressful this kind of work could be. 'The people we are seeing are quite young and it can be very difficult to come to terms with losing patients you have come to care for,' he said. Much thought was given to make sure the décor was relaxing, with airy rooms painted pale blue, each with an ensuite bathroom. Complementary therapies were available and medical white was banned – and staff dressed in calming blue. There were to be six beds, but that would expand as the need arose. The Sussex Beacon was the first purpose-built hospice in England and Wales for people with AIDS.

These are some of the facilities offered by The Sussex Beacon as published in the 1992 report:

1. Nursing support for people convalescing.
2. Respite care for people finding the illness too hard to cope with.
3. Emotional counselling.
4. Overnight facilities for partners or friends.
5. Day-care services for those living at home.

The Sussex Beacon's charity shop on Old Steine. (© Janet Cameron)

THE BRIGHTON BANDITS GET STARTED . . .

Brighton's gay football club was launched in 1997 and, in 2006, they achieved one of their finest moments as the Brighton Bandits, by winning the coveted League Cup.

In 1997, members of the Gay Football Supporters' Network (formed in 1989) entered a five-a-side team in the GFSN National Tournament in Blackpool. A grant was awarded to the team in 2002 from the Scarman Trust. Together, with further support from The Amsterdam Hotel, who had helped at the inception of the team with shirt sponsorship – the Brighton Bandits became a fully formed, eleven-man team and finished third overall in the national league in 2003. More valuable funding came from Brighton Pride in 2004 and further successes followed: three-time winners of the GFSN Bristol Five-a-Side Tournament, as well as winners of the Leicester Six-a-Side and they were also National Five-a-Side champions in 2004 at Blackpool. In 2005/6, a one-nil away match against Village Manchester enabled the Bandits to win the GFSN National League that year.

An article by Rachel Pegg in *The Argus*, dated 4 December 2007, reviews a film directed by Ian McDonald charting the activities of the Bandits during their triumphant year of being league champions. The lads talked freely about their relationships, personal stories and what they thought and felt about homophobia. Ms Pegg concluded, 'This was a very funny film which allowed the Bandits to shine.'

You can find an excellent video of The Brighton Bandits on www.youtube.com.

The Amsterdam Hotel. (© Janet Cameron)

'COUNT ME IN' – A PROJECT FOR THE NEW MILLENNIUM

On 16 August 2000, an article appeared in *The Argus* about the 'Count Me In' project, an initiative to evaluate the wants and needs of the LGBT community in Brighton and Hove. The report suggested that Brighton and Hove was the place to be if you were a gay man or a lesbian; all the same, very little was known about the needs of the gays and lesbians in the town (at that time estimated to be between 20,000 and 30,000).

As a result, the 'Count Me In' survey was launched and handed out earlier in the month at Pride. 'It contains 158 questions about the ethnicity, personal habits and lifestyle of gays and lesbians with special sections for women and transgendered people,' said *The Argus* report. The project cost around £16,000, was being funded by the council and health authority and involved about twenty-five gay and lesbian groups. One of the points made by Paul Martin, who worked for the authority, was that it was more effective for all groups to pool resources, rather than a number of smaller groups having to compile their own surveys. 'In areas like drugs, alcohol, mental health, relationships and housing, we know practically nothing,' he said. 'We hope to reach well over 1,000 lesbians, gay men, bisexuals and transgendered people through the survey alone.'

Commissioned by the Brighton and Hove Regeneration Partnership, the results of the survey would help towards the overall regeneration strategy for Brighton and Hove. It was also hoped to attract government funding. Included in the scheme were representatives from Brighton Lesbian and Gay Switchboard, the Terrence Higgins Trust South, the council and health authority and Gay and Lesbian Arts and Media.

Joan Beveridge, project director for GLAM (above), said one of the aims was to focus more attention on lesbians who had been left out of the spotlight. Ms Beveridge said, 'As a result of HIV and AIDS, gay men's health matters have been highlighted but nothing has been done to address lesbian health needs. Within Brighton and Hove, the lesbian community is being largely ignored.' Questionnaires would be made available from gay and lesbian pubs, clubs, businesses, from council libraries and offices.

WORRYING TRENDS

Several years later, had things improved? An article in *The Argus*, dated 18 June 2007, by Lawrence Marzouk claimed that three quarters of the LGBT community in Brighton and Hove had been verbally or physically assaulted in the past five years. Most victims felt that their sexuality was central to the issue. The statistics emerged from 'The Count Me In Too' report organised by the University of Brighton and Spectrum, Brighton and Hove's LGBT forum. The 'Count Me In Too' project was initiated in 2005 to address mental health issues among the LGBT community. Their 2008 report addresses, among other issues, isolation, mental health difficulties and domestic violence by a partner and also during childhood. Almost 900 men and women were interviewed from the 35,000-strong LGBT community in the city.

Mr Arthur Law, the coordinator for Spectrum, the LGBT community forum, is reported as saying, 'The city has long been a home to and refuge for LGBT people. Only together, as individuals, groups, services and planners, can we ensure we build on these foundations to lead the way in tackling inequality and discrimination and championing a model of LGBT inclusion the city can be proud of.' One young man participating in the interviews said, 'There's a lot more talking than there used to be and a lot more listening but I still hear about things going on. There are still people getting beaten up.'

Their university's findings are ongoing and will be published in due course with their recommendations for change.

THE BRIGHTHELM METROPOLITAN CHURCH

In 2001, Debbie Gaston got together with six other people to create a church for all people regardless of sexual orientation. They found a venue in Brighton Gay Village with a glass cross in the front wall of the building that made everyone feel it was a real place of worship. On 19 May 2002, the church, originally known as 'Brightwaves' became a reality. When Debbie was ordained the following December, the church became an MCC in its own right, with its own vicar, board and members. After a year, the original seven had increased to thirty-seven.

Debbie's vision is far-reaching and inclusive. 'Only people can limit God's Spirit and, in reality, God's love for humanity is limitless. God has made each of us in a unique way and we celebrate the diversity of all that God has made and therefore all that God is.'

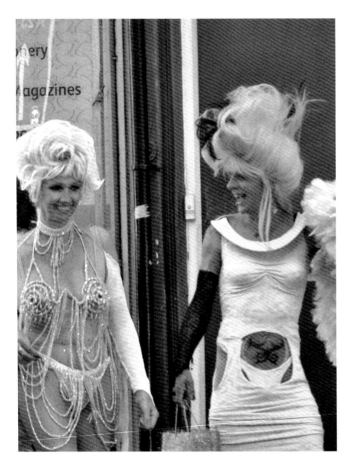

Gorgeous in green, Pride 2004.
(© www.aspexdesign.co.uk)

A BEAUTY PAGEANT TO FIND MISS TRANSGENDER

In 2004, a beauty pageant was initiated to raise the profile of transgendered people and this was to include transvestites, cross-dressers, drag queens and transsexual people. Part of the mission statement of the transgender charity, The Clare Project, is to challenge transgender stereotypes and to recognise that transgendered people are valuable members of the community. This first pageant was held at The Portland Inn in Hove. In 2005, the event took place at the Sussex Arts Centre in Ship Street, and then, in 2006, it was held at the Kooklub, and reported on The Clare Project website to have raised £1,000 for The Clare Project, The Sussex Beacon and Martlets Hospice.

In 2007, the venue was moved to the Pagini Ballroom of the Old Ship Hotel. In *The Argus* of 2 October 2007, organiser Julie Craig told reporter Katya Mira: 'It is important to have an event like this to show awareness of transgendered people and celebrate their beauty. It is also great fun, raises lots of money for charity and is a good way to get all kinds of different people together. It is brilliant that we have the profile we do and seem to be getting bigger and grander each year.' People come from all over the UK to compete for the titles Miss Mature and Miss Transgender, Brighton. They have to answer questions and then parade in their fabulous costumes.

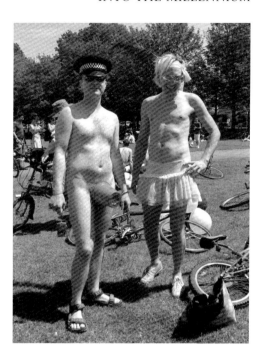

The 2009 World Naked Bike Ride.
(© www.aspexdesign.co.uk)

GAY PRIDE AND THE GREEN PARTY

Many LGBT people, who are traditionally passionate about green issues, actively support the Green Party, which in turn, promotes the rights of LGBT. A letter from Nigel Tart, chair of the Brighton & Hove Green Party LGBT Group, to *The Argus*, Friday 14 March 2008, claims that, since 1999, the Greens have marched at Gay Pride. He says, 'The party has an active lesbian, gay, bisexual and transgender group, developing local policy and supporting our councillors.' Certainly, as Mr Tart claims, the Greens have made 'the most comprehensive local election pledges on LGBT issues, which all our councillors are fully behind.'

WORLD NAKED BIKE RIDE

Like the Pride Parade, this is not an event exclusively for LGBT people but for everyone. On 7 July 2008, the cyclists began at The Level, rode across town and through the shopping centre, past the Pavilion and finished on the Naturist Beach. In 2009, there were over 700 participants, many with bodies painted and decorated, bringing the traffic to a halt in Old Steine.

 The aim of the event is to highlight cycling as a green alternative to cars; the emphasis: the value of the individual. The nudity draws not only extra publicity from the media but also evokes the vulnerability of cyclists. T-shirts sporting slogans such as 'PASS WIDE AND SLOW - I AM EASILY HURT' and 'PEDALS SAVE PETROL' help publicise the message. Again, as with Pride, the bike ride is far from elitist; the 2008 ride included a naked jogger and a naked rickshaw driver.

RELATE JOINS WITH SWITCHBOARD TO HELP BRIGHTON AND HOVE'S LGBT

An article entitled 'Marriage guidance for city's gay couples', appeared in *The Argus* on 17 October 2006. The Relate charity had set up shop in conjunction with Brighton's Switchboard Counselling Project to serve Brighton and Hove's lesbian, gay, bisexual and transgendered people with support through difficult times. The manager was Trish Owen, who pointed out that LGBT people have the same relationship problems as those in heterosexual relationship. She explained they also had specific problems.

'Around Christmas, if one partner has not come out to their family, do you take your partner home?' It was essential to set up this special counselling service, so LGBT couples would feel comfortable approaching Relate, who had been formerly regarded as a heterosexual organisation. There was a similar scheme in Manchester, from which Ms Owen found her inspiration. At that time, Brighton and Hove had just celebrated its 600th civil partnership. 'Historically,' said Natalie Woods of Switchboard, 'LGBT people have been identified in the mental sector as pathological. If they approached counsellors for help, they could be treated accordingly.' Also, certain issues affecting LGBT people are sometimes not seen by society as equally valid, for example, the largely unrecognised problem of same-sex domestic violence. As one trainee said, 'As a gay man, I understand the pressures there are on relationships and the pressure there is to make and sustain a relationship.'

The Big Lottery Fund and Switchboard offered to help fund the service and suggested people should start thinking about a good name for the service with a Body Shop voucher as a prize. Now the service is known as PROUD2CONNECT.

WE'RE GETTING THERE!

The Argus of 9 February 2007 reported new anti-discrimination laws coming into effect in April would make it illegal to cater for a gay-only clientele. Legends' marketing manager, Arran Pawson said, 'We haven't got a problem with the law and will follow it. It will not affect us and it doesn't make any difference.' Alex Matthews of the Amsterdam Hotel in Marine Parade agreed with him. 'I was hoping by the time I got old, we would not have specific venues – it is getting there.'

29

COMING OUT

SOME PERSONAL ACCOUNTS

'It can be a fraught thing. I remember this from coming out: you are making a statement that straight people don't have to make, drawing attention to yourself,' says novelist Sarah Waters in the book interview by Claire Allfree in e-Metro, dated 4 June 2009. Here are accounts from a lesbian, two gay men, a bisexual man, a transgendered woman and a gay man's mother.

A PERSONAL STRUGGLE

'Coming out is different for different people,' says Revd Debbie Gaston of the Metropolitan Church. 'Each person handles it in their own way.' Debbie was a teacher in Harrow, Middlesex, before she became a reverend, so she suffered the fear of losing her job if she came out as a lesbian. She first became aware of her sexuality at around aged thirteen, and then, at fifteen, she became a Born Again Christian. At this stage, she experienced a deep, personal struggle between her sexuality and her faith.

Debbie Gaston at Pride 2007, with permission.

She says she came out gradually, rather than all at once, and in the beginning she only confided to one or two close friends. Then, in 1998, she worked in a school where several of the staff were lesbians. They recognised that Debbie was also a lesbian, and because they felt comfortable about their sexuality, it gave Debbie increased confidence. 'It helps to be with like-minded people. I began to feel more relaxed about myself and that in turn made others feel more relaxed with me,' she says.

Her father had died in 1997, unaware of his daughter's struggle with her personal identity. Soon after, in her late thirties, Debbie decided to talk to her mother. Her mother had not suspected the 'secret' that Debbie had felt obliged to keep from her, but she responded in a calm, supportive way.

'You're still the same Debbie,' she said.

OKAY TO BE GAY

John McPherson has been running a Brighton pub with his partner, Phillip Fifton, for three years, but he grew up in the East End in the seventies. 'It was tough, really tough,' he says. John suffered frequent abuse but the insult he hated the most was when people called him 'Pretty Boy' because of its mocking sarcasm.

John is a twin and both are gay, but they told their mother separately. John says she was understanding and told each of them that all she wanted was for them to be happy, although she didn't entirely understand their sexual preference. It was harder talking to their father. He did not understand it at all, although he did, eventually, come to terms with the boys' sexuality. However, he found it 'disgusting' to see men kissing, says John.

John explains, 'People are only bigoted because they are unsure about their own sexuality.' This is 'internalised homophobia', a prejudice that centres around the fear inside individuals that they themselves might have homosexual tendencies that they find difficult to reconcile with their own social values, beliefs or religion. On the other hand, 'social homophobia' is the fear of being identified as homosexual, and so social homophobes try to distance themselves from any contact with LGBT people in order to protect their role as a heterosexual within society, in other words, as 'normal'. One thing John stresses very firmly is that it is never okay to 'out' another person. It's something that can only happen when you are ready.

'But I'm fine about being gay now and about who I am,' he says. He is proud of his handsome looks and the confidence he gained from acting prior to taking on the pub. He has acted in several primetime television dramas, for example, *The Bill*, *Casualty* and *EastEnders* and once danced in one of two cages on a television set for a Jo Brand comedy programme. 'At the end, she had to spit at me,' he laughs.

THE ONLY ONE?

'My brother tried to knock it out of me when I was seventeen,' says Ron Forrest. But after that incident in 1949, it was obvious Ron would not change. No one in the family ever talked about it, although recently Ron's nephew, now fifty, told him he had always been described as 'the black sheep of the family'. Ron says that, before he was seventeen, he thought he was 'the only one', but a school friend with more experience introduced him to gay bars, and he began to meet people in The Greyhound (now The Fishbowl) in East Street in an upstairs gay-friendly bar.

Unlike many gay people during the twentieth century, Ron never got into trouble with the police, perhaps because his sexual preference is not obvious. He was a furrier for a time, and then, in 1971, became a hospital porter and later a store's invoice manager. Finally, he became the office manager for the Sussex County Hospital. There were already two or three gay people working in the hospital and Ron was never discriminated against at work. Now Ron Forrest is in a loving, committed relationship with his partner, Warren Nelson, and their wedding story is told in the next chapter, Civil Partnerships.

The Fishbowl.

THE FIRST GAY THOUGHT

One bisexual Brighton man says, 'It's not easy being gay, bi or whatever these days, but going back even a decade ago it was much harder.'

Oliver (not his real name) had a boyfriend for some years and when that relationship ended, he fell in love and married his present wife. The marriage is successful and his wife and child know about his boyfriend. However, he hasn't come out to some of his friends about his past.

He remembers being at school, around 1985, when he was eleven. One of his male friends bent over in front of him and Oliver had his first 'gay thought': 'What a great arse!' Oliver was scared and had many sleepless nights, trying to convince himself his friend had a feminine bottom and that was why he was turned on. 'Quite frankly, it scared the shit out of me! I could not possibly be having thoughts like that. Back then you did get the occasional token 'poof' on TV, but most were totally camp and seemed to be there to be made fun of. It wasn't at all what I wanted to be like when I grew up.'

There were no role models for Oliver, who didn't know anybody who was gay, at least, not that he was aware of. 'It was still very hush-hush back then. I remember so many people were homophobic. These days, life is a lot easier and many people know I'm bi. Those who don't probably wonder about me anyway.'

DON'T LABEL ME PLEASE

'I have a detestation of labels,' says Norma, one bisexual, transgendered woman. 'I refuse to admit there's more of a difference between men and women than the sexual organs. If you choose to live as a man, then you're a man. But if you choose to live as a woman, then likewise.' Norma says that she's now come to the realisation she prefers relationships with men, but she still enjoys acting out her alter egos.

I KNEW FROM THE TIME HE WAS A TODDLER

A Brighton woman, whose son was born in the seventies, says she knew he was gay from when he was a tiny boy. Her son loved the things most small girls enjoy. He absolutely hated getting messy and threw his arms about in disgust, demanding to be cleaned or removed from the source of his discomfort. He was also passionate about playing hairdressers with his sister, to the little girl's constant irritation. Their mother didn't tell the father she thought their son would be gay. 'My husband would never have understood,' she says. She kept a low profile and waited until he was ready to 'come out' on his own and tell her. 'I think he found it quite hard,' she says, 'but now it's fine and he's very comfortable with his sexuality.'

30

CIVIL MARRIAGES
AT LAST, A CHANCE FOR RECOGNITION

Sarah Mendelson and Patricia Crawford, in their book *Women in Early Modern England* (Oxford University Press, 1998), mention a 1680 court case regarding the marriage of two women.

Arabella Hirst, who later became a musician in Queen Mary's Court, dressed as a man and married Amy Poulton in a church ceremony, but after six months the marriage broke down and was annulled by the London Consistency Court. Aphra Behn's play *The False Count* (1682) is thought to refer to this case. One of her characters says: 'I have known as much danger under a Petticoat as a pair of Breeches. I have heard of two women who married each other – oh abominable, as if there were so prodigious a scarcity of Christian Man's Flesh.' As the author comments: 'Behn was publicly airing the possibility of lesbian marriage.'

On 21 December 2005, civil partnerships for gay and lesbian couples became legal in England and Wales. Brighton was way ahead with 198 ceremonies set to take place before the year's end, according BBC News, 5 December 2005. Brighton also scored the highest number of bookings in the entire country, estimated at the time as 510 for the year ahead. Stonewall campaigner Alan Wardle said, 'Our view is that civil partnerships are transformative for the lives of individual couples and their rights, but also for society more generally. Society now recognises gay relationships for the first time.'

This long overdue change in the law has meant a great deal, especially for gay couples who have been in committed relationships for many years but felt themselves invisible in society. People who have taken advantage of the new law include an eighty-year-old couple who have been together most of their adult lives.

'THIS IS THE LOVE OF MY LIFE'

Ron Forrest and Warren Nelson have been in a gay relationship for ten years and had two ceremonies. On 24 January 2003, the first ceremony took place at Brighton town hall and was recognised by the council, although their document was of no legal value. Then, exactly three years later, on the anniversary of that commitment ceremony, after the law had changed, they had an official civil partnership ceremony. They now wear gold-band rings from their first commitment ceremony on their left hand, and on their right hand, each has an identical diamond marriage ring.

'We have an anniversary every month,' says Ron. 'On the 24th, we go out to dinner and celebrate.'

Ron says he's had a few long-term relationships in his life. From 1957 to 1963, he had a partner, Malcolm. Then, when his relationship with Malcolm ended, he was with Robert for several years. 'Our relationship ended in 1968. We had a house together but when the relationship began to deteriorate, we turned the house into two flats. After Robert sold his flat, I was on my own,' says Ron.

'This is the one, though,' adds Ron, 'Warren is the love of my life.'

'A DAY THAT MADE OUR SOULS GRIN'

Kate Wildblood and Queen Josephine also had two ceremonies. The first was in 1997. 'Totally unofficial and so not legal,' says Kate. 'This was a day full of real love. We got wed in a garden full of friends and family. We felt so loved that day, it was amazing.'

It was important for the couple to make a real show of their commitment to each other, but they felt not everyone took it seriously. So when the 'real thing' came along, they decided to make it official. It gave them the reassurance of knowing if anyone refused either access to the other, or equal rights in work, health care, etc., the law would be on their side. 'But really, it's about love and the commitment we have for each other,' says Kate. 'Also, the love and support of our friends, families and colleagues – and ours for them.'

Kate and Josephine, both DJs, met through clubbing. Kate ran a club called Shameless Hussies and she rang Josephine to play percussion at the club. 'If I'm honest, it was all about lust in the beginning.' When they first met, Josephine came to Kate's flat and Kate followed her up two flights of stairs. 'I spent two minutes in the company of her fine arse! And that was enough to tell me I had to have this lass. I could tell you that once she spoke, and we shared thoughts on life, philosophy and the like, I was hooked. But it was the arse all along! Really!'

'We drank and flirted in a pub for hours,' continues Josephine. 'We were both living with other girlfriends, so we had to settle for a snog in a shop doorway. I knew Kate was the girl for me. After I dragged myself away from her to return home, I walked straight into a lamppost. I've never been the same since.'

On 8 March 2008, the couple was driven to the registry office in their mate's ribbon-covered gold Citroën DS. They felt, considering the system we live in, that they were making a huge statement, two women getting wed, with people staring at them and their family and friends around them.

'Trevor Love, the registrar, is amazing. It was like being married by a cross between Larry Grayson and a favourite uncle. We couldn't stop grinning all day,' says Kate. 'We were surrounded by loved ones and you can never have a bad day when that happens.'

So everything was wonderful, even though the wind blew, the rain poured, the reception venue wasn't ready on their arrival, the DJs played too loudly and a fire alarm went off at 5 a.m. in their honeymoon hotel! Josephine's father made 'an amazing speech' which touched both of them, despite references to Kate's Essex roots! All the families' children were there. 'We loved the fact they just saw the day as Kate and Jo's wedding and not some odd lesbian "do".'

Kate and Jo say how well they complement one another, in and outside the bedroom. 'The lust has never ended, which still amazes us.' Kate calls Jo her 'funny little thing' because she makes her laugh and she loves her for that.

'Whatever life throws at us, we can get through it together.'

Kate and Josephine – family photo with permission.

'LOVE SUPERSEDES ALL'

'Brighton and Hove has led the way in civil partnerships and we are so proud to call this fabulous city our home.' So say Graeme and Jamie, who, on 21 December 2006, aged forty-one and thirty-six respectively, became the 680th gay couple to become civil partners in Brighton and Hove. The couple met in 1994 and chose to hold their ceremony at Brighton town hall on the first anniversary of the day civil partnerships were made legal for gay couples. One hundred relatives and friends celebrated with them, including their white boxer dog Humphrey.

The couple's bridesmaid was Joan Bond, a glamorous drag queen famous for leading the parade at Brighton Pride. The ceremony was officiated by senior registrar Trevor Love, a personal friend of the couple. Afterwards, the Brighton and Hove (Actually) Gay Men's Chorus gave the couple a special performance in Bartholomew Square.

Jamie said, 'We've been together a very long time and it's great to do it here in the city we love and have made our home. That makes today extra special.' His stepmother, who lives in Surrey, agreed. 'We are very happy for them. Love supersedes all. That's what life's all about.'

Two years previously, the men exchanged 'commitment rings' made from a melted-down heirloom from Jamie's grandmother. This heirloom contained two diamonds, so they had one each. They'd thought about legalising their partnership around the end of

Jamie and Graeme, Jamie is on the left.
(© Adam Tayler, www.qshoot.co.uk)

2005, when the law allowing civil partnerships was first passed, but decided to wait a little, just to see how seriously people would take it. Graeme and Jamie, who together run a property investment company started by Jamie's late grandfather, live in Hove having moved down to the city from London in 2002. Jamie is a former volunteer board member of Brighton Pride and was co-owner of the Brighton-based gay magazine, *3SIXTY*, until its sale in 2008.

FAMILY AFFAIR

Julie and her partner Suzie (not their real names) met when both were living in Brighton. The couple welcomed the new law allowing them to marry and legalised their relationship in early 2009. They moved away when Julie recently took up a new post in the medical sector. When they decided they were ready to have a baby, a male friend said he was willing to act as a donor and so Julie, a nurse, implanted Suzie with the donated sperm. When Suzie had her baby, Julie's mother left Brighton to join her daughter and daughter-in-law in their new town so she could be readily available to help with the baby. All three mothers, those of the couple and the biological father, are delighted with their new family unit.

To make their family complete, (and keep the grandmas busy!) Julie and Suzie are now thinking about having another baby by this method within the next year or so.

Phillip and John, Phillip
on left. (© Paul Chessell)

WEDDED AT THE WEST PIER

'We married near the old West Pier in Brighton,' explains John McPherson, 'because that's where Phillip first proposed to me and we both wanted that.' John McPherson and Phillip Fifton have been running The Prince Albert in Dean Street for three years now and have built up a regular clientele. They also host events for stand-up comedy, where everyone has a great time.

The wedding ceremony took place on Tuesday 25 November 2008. 'If someone offered me a pill today that I could take to make me straight, I would never accept it,' says John, 'I like my life and if I was reincarnated, I would choose to be gay again.'

31

PRIDE IN THE TWENTY-FIRST CENTURY

It wasn't going to be perfect, but the New Millennium brought more positive changes. Lobbying and a continuing refusal to back down in the face of opposition began to pay off. The Pride Parades embodied a defiant yet vibrant spirit of unity between LGBT people and the gay-friendly community. There are also 'Winter Pride' fund-raising events, but due to lack of space, this chapter is restricted to Summer Prides only.

PRIDE 2000 – SILVER SCREEN

It was a hot day for Pride 2000, which took place at the end of July. The Hollywood theme inspired a plethora of film stars, including Joan Crawford and several versions of a sultry Marlene Dietrich. Party events included Wild Fruit's dance tent, a cabaret, line dancing, a market and a funfair. The only gripe seemed to be that the after-party venue held at the Concord was too small and many people were disappointed at being unable to get tickets.

THE PRIDE THAT ALMOST NEVER WAS

Prior to this largely successful Pride, there was dissent between two rival factions, Brighton Pride and Pride 2000. Reports from *The Argus* on 15 December 1999 and 5 January 2000 indicated that feuding had threatened the festival. Brighton Pride had run Pride for the previous three years and submitted its bid for 29 July. But there was a competitive bid from new organisation Pride 2000, aiming to run their festival on 12 August. After the council met to choose which festival should proceed they decided not to approve either application. The council told the rival parties to sort it out and submit a single bid. Brighton could not support two Pride festivals and everyone was worried. If the rivals could not compromise, the event would have to be abandoned.

The parties failed to reach an agreement. The organiser of 'Brighton Pride', Sue Nichols, was offered the opportunity to apply for a position as director on four occasions, but declined, feeling her team were 'left out in the cold'. She felt it would be selling out to a commercial venture and instead counter-proposed that two of the Pride 2000 team should work alongside her team.

Brighton Pride said, 'Our event is the most successful gay and lesbian festival in the UK. We have an excellent track record and an outstanding reputation where others have failed.' But Nimrod Ping, joint chairman of Pride 2000 disagreed: 'Brighton Pride

doesn't have a bid that works. They have no support from the community and no sponsors. They are dead in the water. We have three major sponsors and fifty-six local organisations involved. We're next year's Pride. We will speak to Brighton Pride if they want to.'

On 11 January 2000, *The Argus* reported that one rival was 'not too proud to stand down'. The organiser of Brighton Pride withdrew her application. She had no wish to bring public ridicule to the lesbian and gay community or jeopardise Pride, ending fears that the event, which had topped 35,000 visitors in 1999, would be cancelled.

'I hope we can now all work together and make this summer's festival the best we have seen,' said Nimrod Ping. Ian Duncan, executive Brighton and Hove councillor said, 'They have to turn words into action and make the event work.' Pride 2000, said to have the support of most of the LGBT community, was free to go ahead.

PRIDE 2001 – MYTHS AND LEGENDS

60,000 people attended Pride 2001. There were fairies and fruit to endorse the Myths and Legends theme as well as the ubiquitous Greek Gods. Sadly, there was a string of homophobic assaults after Pride, reported in *The Argus*, dated 13 August 2001. An eyewitness reported an attack in St James's Street that occurred late on the Saturday night. 'It was horrendous. It started when a group of fifteen to twenty from outside the Kemp Town area of Brighton walked down George Street to target people coming out of the Queens Arms. They were shouting Nazi slogans and anti-gay comments.' One of the gay men tried to defend himself, resulting in pushing and shoving, and as the thugs walked into St James's Street, the man was attacked and kicked as he lay on the ground. Police vans arrived, and later two men were arrested.

Another attack occurred at 11.40 p.m. in Queens Road when two men began abusing four other men, one of whom was taken to Royal Sussex County Hospital, while another was cut by glass. The two attackers ran off towards Brighton railway station. Police believed the thugs travelled to Brighton specifically to target gay men.

PRIDE 2002 – GLAM AND GLITZ

This festival is commented on most often – for the mud. There was a downpour at the beginning, then it started brightening up but the party at Preston Park was waterlogged, inspiring some feisty mud-wrestling, much appreciated by the crowds. This was the first Pride for Brightwaves Metropolitan Community Church, who created a fine, colourful float. Many of the members of the present-day congregation found the church through Pride. The church believes, unlike many other denominations, that God welcomes everybody to God's house, regardless of their sexual orientation.

There were about 50,000 people at this Pride on Sunday 11 August 2002, and when the rain started again in Preston Park, everyone raced for the tents. The maths wasn't on their side – only a few could get undercover. There was a long queue for the show at the dome, then followed a small fire and everyone had to be evacuated. An incident occurred during the day when three drunkards attacked a drag queen and were arrested by the police.

PRIDE 2003 – THE GREATEST SHOW ON EARTH

This Pride festival attracted around 90,000 people and reported sixty-four floats and walking tableux. The sun was beaming down on the parade on Saturday 7 August, reportedly the hottest day of the year and the most successful Pride to date, with an eye-catching Real Brighton float all decked out in red and white. *Gay Times* and *Boyz* magazines proclaimed the day the Best Pride.

For award-winning photographer Dean Thorpe, it was an embarrassing day. He was painfully shy. He chose a costume of black tracksuit trousers, a black t-shirt and had his face painted as a tiger with a tiger headband to match. The final touch was a fine, fluffy orange tail. 'I'd been having problems getting the tail to stay on,' he says, 'so I tied it onto the back of my pants.' This worked out fine until Dean was in the centre of Preston Park. 'It seemed like there were about 100,000 people around me, when somebody had the fun idea of pulling my tail. There I was, with loads of people standing and staring at me while my trousers and pants were round my ankles!'

Dean was on crutches at the time, and had a struggle to get his trousers up. 'It was a nightmare for the 'shy me' at the time, but it gives me a good laugh these days, says Dean. 'I just hope nobody had a camera!'

PRIDE 2004 – THE HIT PARADE

True to its theme, Pride 2004, held on 7 August, was a 'hit'. Not only did *Gay Times* and *Boyz* magazines claim this to be the Best Pride (Brighton Pride also won the previous year, see above), in September 2004, Brighton Pride was awarded charitable status. To top this, Brighton Pride 2004 also won the Event of the Year Annual Brighton & Hove Business Award.

Present at Pride 2004 – with its Hit Parade theme celebrating thirty years since ABBA won Eurovision at the Pavilion – were a large number of look-alike icons, for example: Elton John, Madonna, Bette Davis, Kylie Minogue and the Gay Police Association, which was said to be a 'big hit with the crowd'. Students from the University of Brighton handed out questionnaires, intended to provide an economic, social and cultural evaluation of the event. It was planned to use the survey to help Pride plan future events and assist Brighton & Hove City Council in their understanding of what Pride contributes to the city and its economy.

There was a Pride Couple of the Year event, when seven couples participated in a three-minute commitment ceremony with the support of Pink Weddings in the Pavilion on 7 August. Each couple received wedding pictures, a glass of champagne and certificate and the winning couple with the best personalities were awarded a four-day honeymoon in Quebec. It's claimed the 2004 Pride event brought around £5 million into the Sussex economy – so much for the whingers of the nineties! (See 'Count Me In', page 98).

PRIDE 2005 – HEROES AND HEROINES

On Saturday 6 August 2005, people were invited to dress up as their favourite heroes and heroines, an opportunity for everyone to indulge in creating and being their own

Keeping order, Pride 2004.
(© www.aspexdesign.co.uk)

favourite role model. Events co-ordinator P. J. Aldred said the theme would fire the imagination for creating stunning costumes. 'Whatever the theme, people tend to interpret it quite loosely. I think heroes and heroines will open up a whole raft of ideas and it will be amazing to see what people come up with.'

Wonderwoman, Superman, Shrek, Catwoman, Captain Kirk, Madonna, Boy George, Arnold Schwarzenegger, David Beckham – the possibilities were endless. There were more than forty floats and walking tableux and it's claimed around 120,000 people attended. Sponsorship was much in evidence with floats funded by financial institutions like banks, car companies and charities. Amnesty International's enormous Pink Tank collected money and raised awareness about Human Rights.

PRIDE 2006 – CARRY ON

On Saturday 5 August, 150,000 turned out to join the Guest of Honour for this Pride Parade, the incomparable Barbara Windsor, looking gorgeous as ever. She said how much she loved Brighton. Touchingly, she said, 'I think I'm the only one left,' (of the Carry On team) and she continued that she hoped that the other members of the team would be looking down at her – and wondering 'What that little tart's doing down there?'

Well received was the Carry On Columbus float as well as the Sussex Police, who were much applauded by the crowds, heterosexual officers marching with their gay and lesbian colleagues. It was a very British Pride with plenty of Union Flag boxer shorts on show, as well as the rest of the saucy underwear, stockings, sequins, rippling muscles and sexy pouts.

LGBT BRIGHTON AND CHRISTIAN VOICE

There was a protest by about six protesters belonging to a radical anti-gay Christian group according to the staff writer of *Pink News* (PinkNews.co.uk) in an article of 9 August 2006, 'Anti-Gay Christians lampooned after Pride complaint'. Christian Voice complained to Sussex Police after Chief Constable Joe Edwards became the first police chief in the country to march in the Brighton Pride parade. The Christian Voice director said he felt the Christian faith had been held in contempt. He was deeply offended because there were two men kissing in the street, and, in his opinion, they should have been arrested under the Sexual Offences Act 2003. 'We are standing up for righteousness and preaching a message of repentance,' he said.

A police spokeswoman disagreed. 'We always have a presence at Brighton Pride. Chief Constable Edwards wanted to celebrate the diversity of the police force.' She added it was not an offence for two men to be seen kissing in public.' Another spectator said, 'Most people were there to enjoy the one day of the year when gay people can let loose and join in the carnival atmosphere. Christian Voice was just trying to spoil the fun. Luckily, most people just ignored them.'

HYPOCRISY

This, unfortunately, was not the end of the 2006 'Carry On'. According to *Pink News* (PinkNews.co.uk), in an article by Mark Shoffman dated 25 July 2006, accusations of 'hypocrisy' were exchanged between the Gay Police Association and Christian Voice. The Gay Police Association placed an advertisement in *The Independent*'s diversity supplement that coincided with the EuroPride rally. It showed a pool of blood next to a Bible and the accompanying text said: 'In the last twelve months, the GPA has recorded a 74 per cent increase in homophobic incidents, where the sole or primary motivating factor was the religious belief of the perpetrator.'

A complaint was made and Scotland Yard considered investigating the Gay Police Association. Stephen Green of Christian Voice said, 'It's obvious the Indy advertisement is so over-the-top as to be completely indefensible. The only explanation is that the Gay Police Association has collectively lost what remained of their sanity. In that case, I believe Christian Voice can take much of the credit. No other Christian organisation has done so much that has got under their skin.' Then he added, 'It is the actions of Christian Voice which appear to have tipped them into the clutches of the men in white coats.' Mr Green went on to say that twenty-five years ago, the evangelical Christians were the Establishment while homosexuals were on the fringe, but now everything had 'turned the other way around'.

A spokesman for the Gay and Lesbian Humanist Association told *Pink News* (PinkNews.co.uk) that Christian Voice's actions were hypocritical. Christian Voice had

Christian Voice protest, Pride 2007. (© www.aspexdesign.co.uk)

complained some weeks previously about prominent people being questioned by police for anti-gay remarks. Those questioned by the police said their freedom of speech was being curtailed. It seemed Christian Voice was claiming the right to defame gay people, but the community was not expected to retaliate in kind. Revd Martin Reynolds of the Lesbian and Gay Christian Movement said, 'Of course, Christian Voice are going to celebrate this; the basic premise of the GPA advert is true. Unfortunately some Christians and other religious groups have and do advocate harm to gay people.' He felt that religious fundamentalists were a threat to LGBT people and couldn't be ignored.

THE STREET PARTY

A further disappointment was the cancellation of the street party; there were simply too many people, threatening safety. Notice of cancellation was short and publicans were angered, saying they could have organised something. They were so incensed they decided not to collect money for Pride. It was a great pity as, in 2005, around £10,000 was raised from the street party.

BETTER LIAISON

According to the report in *The Argus* by Ruth Lumley, dated 21 August 2006, LGBT liaison officers in the city created profiles on the Gaydar website, so that visitors could

easily report homophobic incidents and get advice. The project was to be managed by the Kemp Town police.

'We are always trying to think of new ways to encourage the LGBT community to report incidents to us, using methods which are familiar, simple and welcoming,' said Police Community Support Officer Sarah Stanbridge. The police team said they work to link the profiles with the True Vision packs so that people could pick them up from pubs, clubs, banks or the police station. In this way, they could report crime anonymously.

Torsten Hojer from *3SIXTY* magazine agreed. 'We think it's a great idea. We are impressed with the police and the links they've initiated to improve communications between themselves and the LGBT community.'

PRIDE 2007 – MUSICALS

According to *Pink News*, 27 April 2007, the chief constable in Hampshire gave permission for an LGBT police float at Pride. He was concerned that the police ethic of impartiality might be compromised, but decided to go ahead.

A report by Laurence Taylor on the Brightwaves' website tells how the Revd Debbie Gaston blessed the parade. Everyone climbed on board the Brightwaves Metropolitan Community Church float and set off. But there was an unexpected problem. 'The music went quiet,' says Laurence, 'replaced by a half-hearted cough, cough from the generator. Attempts to restart it failed and we realised the worst – we had run out of fuel. No one could help with spare fuel, so it was no music and we had to make do with the beat music of the Southern Sound float behind.'

Laurence continues, 'A bit further round from our stall were the Buddhists, the Quakers and the Humanists (where a very nice man had no hesitation in sending their regards when I told him I was with the Opposition!). Not a trace of the usual 'our god can beat up your god' that we hear so much.'

Several members of the National Front were present and were loudly booed, while some spectators tried to knock down their banners. This resulted in a fight, reputedly somewhere near the Co-op in London Road and the police had to restore order.

The Brightwaves' website is listed with other useful addresses at the back of the book.

PRIDE 2008 – PRIDE AROUND THE WORLD

This Pride was held on Saturday 2 August 2008 with around fifty-five floats and walking tableaux wending their way from Madeira Drive to Preston Park. The cheering spectators were estimated at around 160,000 and about 40,000 were LGBT. They lined the streets, several layers deep, braving the rain. There were as many umbrellas in evidence as there were Pride flags, not only among the spectators but on the floats too. The weather improved later for the party in Preston Park where the song 'If you're happy and you know it' was sung for the benefit of Christian Voice, who were reported to have responded 'very politely'.

The 'Have Your Say' column in *The Argus* of 1 July 2008 included one comment that summed up the general consensus: Toby Singer, 20, was among dozens dancing on

Left: Mr Gay, on left, Pride 2007. (© www.aspexdesign.co.uk)
Right: Dean and Yolanda Thorpe, Pride 2007. (© www.aspexdesign.co.uk)

the Legends Bar and Club float. He said: 'It is just a fantastic opportunity to come and camp it up with the whole world watching. It doesn't matter if you are gay, straight, a Martian or whatever. We're all here to have a good time and that's exactly what we're going to do.'

SUNSHINE INSIDE

The Argus supplement, dated 2/3 August 2008, reported yet another protest at the Clock Tower by Christians opposed to homosexuality, but that was the only spot of trouble in an otherwise perfect day. The paper quoted one young man from London, thirty-four-year-old Gary Caldwell, who said, 'It may be raining but we have sunshine inside, and that's what counts. Nothing can dampen our spirits today.'

PRIDE 2009

For the fifteenth year, St John Ambulance in Sussex provided a reassuring presence at Pride 2009. This leading first-aid care charity receives no public funding for its work, but were on hand, as reported by Mike Cobley in *The Brighton Magazine*, with four doctors,

The Party in the Park, 2009. (© Gareth Cameron)

six paramedics and five nurses, supported by five ambulances. A communications unit, forward incident teams and logistics support crew. Pride's manager, P. J. Aldred, said, 'Pride once again appointed St John because of their ability to resource what is the largest event in Brighton's calendar. St John Ambulance has a great understanding of what is needed for events of this size and their knowledge and advice both before and during the event was a key part of Pride's strategy to provide an event that is both fun and safe for everyone.'

The parade took place on Saturday 1 August and 150,000 people attended. Police Superintendent Steve Whitton is reported by *The Argus* as saying, 'Given the substantial numbers we have seen, it had been a peaceful and successful event with very few isolated incidents.' The best float was voted to be the Brighton Gay Men's Chorus and the Terrence Higgins Trust were chosen as the best walking tableau.

POLITICAL EVENT OR CELEBRATION?

An article by Emily Elliott in *The Argus*, dated Friday 14 August 2009, headed 'Are "gay for a day" crowd ruining Pride?', commented on the progress of Pride since the beginning of the nineties. But *The Argus* had received a number of letters asking what exactly Pride represents today.

'Is it still a celebration of the LGBT community? Does it campaign to challenge prejudice? Or is it now just an opportunity for residents and visitors, whatever their sexuality, to have a party?' It appears some members of the LGBT community are

disappointed, feeling they do most of the fund-raising but other people are 'jumping on the bandwagon' to make money from the event. Its political message is disappearing.'

James Ledward, editor of *Gscene*, LGBT lifestyle, listings and community magazine for Brighton and Hove, is reported as saying: 'This year, at my own magazine, 70 per cent of the columnists were very lukewarm . . . I'm not sure people know why they are doing it any more.' There were still issues that needed to be addressed. Mr Ledward pointed out that bullying was one issue, and that would have made a good theme. City councillor Paul Elgood agreed with Mr Ledward that the event could be more political and cited the case of the bombing of a gay Tel Aviv nightclub this year. Pride should not be just another carnival, and there had to be a political message, which should not become diluted because of the event's success.

The positive outcomes were also voiced in the article, that it should be a celebration involving the whole community. 'We are fortunate to live in a city where the majority of people are so accepting of others, regardless of their sexuality, race or religion,' said Mr Elgood, who suggested that organisers should find a balance between those feeling Pride had lost its 'political roots' and the idea of its being a community celebration.

PRIDE TODAY

While Brighton's gay pride festivals began as political demonstrations in 1991, it's now said to be the biggest LGBT event of its kind in the UK. Pride in Brighton and Hove is a non-profit organisation. Summer Pride celebrates the LGBT community in the city with parades, parties and events. Besides the special Winter Pride events that help to fund Summer Pride, other fund-raisers are 'A Day at the Races' and a 'Dog Show'. The spectacular Pride carnival parade now takes place on a Saturday at the beginning of August. Don't miss it!

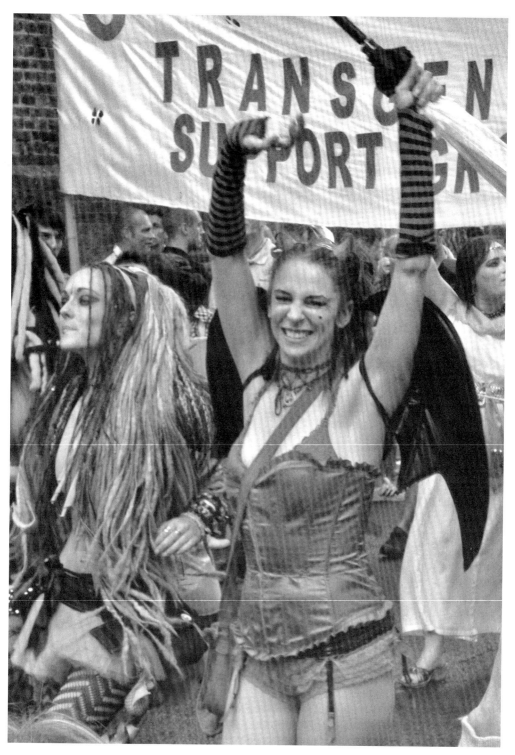

The Transgender Support Group, Pride, 2008 (www.aspexdesign.co.uk)

QUOTATIONS

Latest first:

'I hate labels. LGBT sounds a bit like a utilities service provider!'
Norma, a bisexual, transgendered woman (September, 2009).

'Everyone knows we're gay. But some of us hadn't come out in public as synchronised swimmers.'
Member of 'Out to Swim' in response to a Sky News report featuring London's Gay and Lesbian Synchronised Swimming team (August 2009).

'When I am dressed as a bloke, I don't need permission to do anything.'
Metro reporter Lisa Scott who dressed as a man as an experiment (18 May 2009).

'As someone said, Brighton is a town that looks like it is helping the police with its inquiries.'
Jamie McCartney, Impure Art Gallery (Latest Magazine, 22-28 July 2009).

'Brighton has an estimated gay male population of over 25,000: that's about one in five of its men or four kilometres of dick . . . more "Brighton Cock" than "Brighton Rock".'
– www.outuk.com.

'Don't want to look at men's bums, thank you very much.'
A heterosexual man who didn't fancy going to Pride (2007).

'I think sometimes being gay can be like a PR exercise. At the moment, we've all got to portray ourselves as being completely sane and sorted professional people living in loft-style accommodation, as if all along we just wanted to be simulacrums of the straight people and fit in. Well, some of us aren't and some of us don't. I still believe in the queer perspective.'
David Hoyle, who performed at the Komedia, Brighton (The Argus, 15 May 2007.)

'To tell you the truth, I don't know what really happens to gay people my age on the gay scene. I think you either go into the leather and denim thing or you stay home and wonder about soft furnishings.'
David Hoyle (The Argus, 15 May 2007).

'I hate Brighton, it's so bitchy. Every time I sleep with a guy here they tell everyone about it!'

According to www.mirror.co.uk/celebs, dated 22 September 2003, the above complaint was heard from Julian Clary, who had originally professed to love Brighton:

'Maybe the festival is a little too big for just one period of the year.'

(Evening Argus, 25 May 1992)

USEFUL CONTACTS

Brighton Lesbian and Gay Switchboard, for information and to talk through issues, (01273) 204050, every day from 5 – 11 p.m.

Relate: http://www.relate4u.org/ or email: reception@brightonrelate.org.uk

Gay youth website: www.puffta.co.uk

Support for bi-sexual people: www.brightonbothways.org.uk

Online community for drag queens: www.my-queen.com

Transgendered people: www.gendertrust.org.uk and www.clareproject.org.uk

LGBT victims of domestic violence, national helpline: www.broken-rainbow.org.uk

Brightwaves church: http://www.mccbrighton.org.uk

If you'd like to support LGBT issues: info@stonewall.org.uk

If none of the websites meets your requirements, please telephone the contact at the top, Brighton Lesbian and Gay Switchboard, for guidance.

A great punk hairdo, Pride, 2007 (www.aspexdesign.co.uk)

BIBLIOGRAPHY

MAGAZINES AND NEWSPAPERS

3SIXTY magazine
Pink News
The Brighton and Hove Herald
The Brighton Argus
The Brighton Gazette

The Brighton Magazine
The Brighton Patriot
The County Journal or *Craftsman*
The Observer
The Sussex Weekly Advertiser

BOOKS

Arnold, Roxane and Olive Chandler (eds), *Feminine Singular, An Anthology* (Femina Books Ltd, 1974).

Carpenter, Edward, *My Days and Dreams* (1916).

Hastie, Nickie, *The Muted Lesbian Voice: Coming Out of Camouflage* (1989).

Mason, Michael, *The Making of Victorian Sexuality* (Open University Press, 1994).

Mendelson, Sarah and Patricia Crawford, *Women in Early Modern England* (Oxford University Press, 1998).

Norton, Rictor, *Homosexuality in Eighteenth-century England: A Sourcebook* (http://rictornorton.co.uk/eighteen, updated 31 May 2009).

Radclyffe Hall, Marguerite, *The Well of Loneliness* (Virago Press, 1990, first pub. Jonathan Cape, 1928).

Rose, Phyllis, *A Woman of Letters – A Life of Virginia Woolf* (Pandora Press, 1908).

Rowbotham, Sheila, *A Century of Women* (Penguin, 1997).

Souhami, Diana, *Gluck, Her Biography* (Weidenfeld & Nicholson, 2000).

Spurling, Hilary, *Ivy, The Life of I. Compton-Burnett* (Richard Cohen Books, 1995).

WEBSITES

www.afterellen.com
www.brightonourstory.co.uk
www.gay.brighton.co.uk

www.gayhistory.com
www.geograph.org.uk
www.PinkNews.co.uk

Pride, 2009 (© Gareth Cameron)